Shooting The Pistol

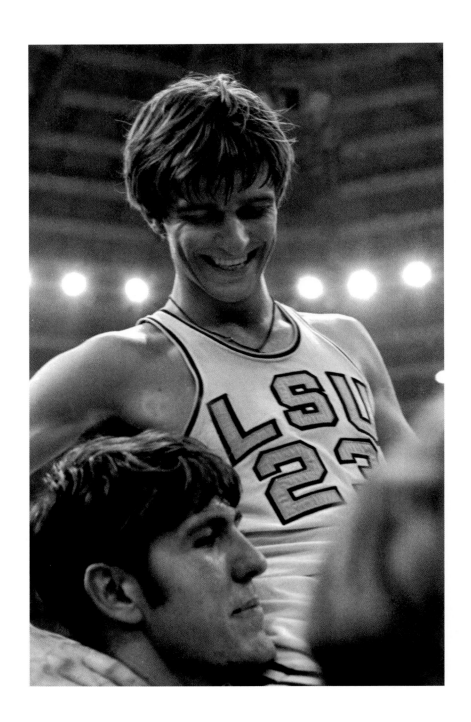

Shooting The Pistol

Courtside Photos
of Pete Maravich at LSU

DANNY BROWN

Louisiana State University Press

Baton Rouge

Published by Louisiana State University Press
Copyright © 2008 by Louisiana State University Press
All rights reserved
Manufactured in China
First printing

Designer: Laura Roubique Gleason
Typefaces: Minion Pro, text; Clarendon BT Condensed, display
Printer and binder: Dai Nippon Printing, Inc.

Except where otherwise noted, all photographs are by Danny Brown.

Library of Congress Cataloging-in-Publication Data

Brown, Danny, 1947–
 Shooting the Pistol : courtside photos of Pete Maravich at LSU / Danny
Brown.
 p. cm.
 ISBN 978-0-8071-3327-9 (cloth : alk. paper)
 1. Maravich, Pete, 1947–1988. 2. Basketball players—United
States—Biography. I. Title.
 GV884.M34B76 2008
 796.323092—dc22
 [B]

 2007034398

For Anna Mae and Pete,
 who made my impossible dream come true.

Contents

Shooting The Pistol

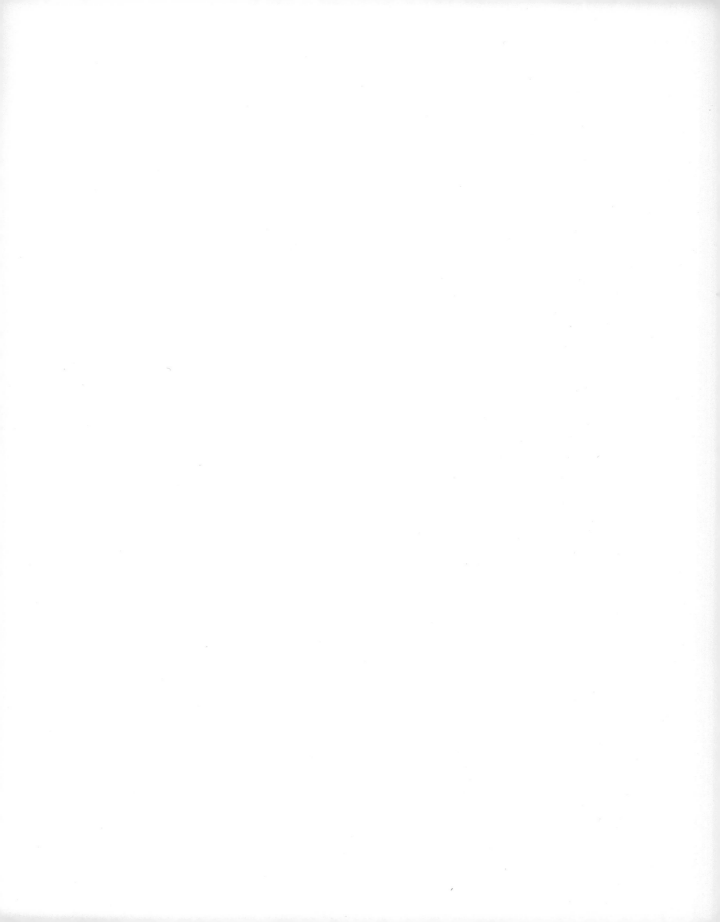

Introduction

I can still remember the first time I saw Pete Maravich. It was not on a basketball court, and I didn't even know he played basketball. I was a sophomore at Louisiana State University and Pete was a freshman. At that time, all male students were required to take Reserve Officer Training Corps (ROTC) for the first two years at LSU. I was the squadron sergeant for 1st Squadron, LSU Air Force ROTC.

Just before the school year began in the fall of 1966, I and the officers of the squadron were tasked with putting the freshmen assigned to the squadron through orientation. This meant teaching them to march, marching them around campus to familiarize them with various locations, and generally getting them ready to begin classes. As the 20–25 freshmen stood at attention in formation on the first day of orientation, I began to call roll. When I got to this name that I couldn't pronounce at first glance, I looked up at the freshmen and said, "Who in the heck is P. P. Mara . . . Mara . . . Maravich!" That's when this kid raised his hand and said, "That's me." (By the way, the "P. P." stood for Peter Press, not "Pistol Pete.")

Now to get this picture in your mind, you must remember that all male freshmen in those days were required to shave their heads and wear a little purple-and-gold beanie with "LSU" printed on it. On the upturned bill, the freshman wrote his last name in the middle, "DOG" on the left side, and "SIR" on the right side. This beanie looked like a deformed miniature baseball cap and made all the freshmen look like what we would call "dorks" today.

The thing I remember most about this scene is that when Pete raised his hand, he looked like a pencil—tall and scrawny thin. But for some reason, I also recall his eyes setting off that scrawny look. They were like huge dark orbs. Why I remember them, I don't know. Maybe it was because his thin pencil shape just brought the accent to that part of his face. As I went to call the next name on the roll, I suddenly realized that I had just read that last name in the newspaper that morning. It was the last name of the new LSU basketball coach, Press Maravich. I again looked at Pete and said, "Isn't that the same last name as the new basketball coach? Are you any kin?" Pete simply answered, "Yes, that's my dad." I never gave it another thought and resumed calling roll.

1

It was not until later in the year, late November or early December I believe, that I found out Pete played basketball. I was not a basketball fan and did not follow it—especially in those days. The basketball team was horrible! Football was my interest. One day, a friend of mine from high school, Sam Raney, a dyed-in-the-wool basketball fan, stopped me in a conversation we were having and said, "Danny, you've just got to go see the freshman basketball team play. They've got a guy out there scoring 40 points a game!" My reply was skeptical. "The guy must be some kind of hot dog." That was a term we used in those days to refer to a ball hog. Sam said, "No, no, no. It's Maravich. He's in your squadron!" All I remember saying was, "That kid can play basketball?"

That beginning brings us to this book. This is not a book about the life of Pete Maravich. That's already been done—several times. Rather, this book is probably the single most complete collection of photographs of Pete when he played at LSU. I am honored to say I took every one of them. I hope this book serves as a time machine for the reader whereby he can put himself there where I was, a front-row spectator, under the goal, witnessing firsthand the making of college basketball history at LSU and in the nation.

Pete Maravich is certainly the greatest basketball player in LSU history, and, in my opinion, the greatest to ever play college basketball. That's a fairly bold statement, but I know that almost anyone who was actually there to watch will surely attest to it.

My perspective on Pete Maravich is a little different from most. During Pete's sophomore year, our paths crossed again because I was a journalism major and a photographer. Basketball was one of the assigned beats while in journalism school. As journalism students, we were required to cover certain given subject areas on campus and submit articles and photos for class grades and also for possible publication in the campus newspaper, the *Reveille.* We were graded not only on quality, but on the number of column inches we had published. For a story, we got credit for all of the column inches it occupied. If a photograph was published, we received half-credit for the number of column inches occupied by the published photograph. Therein is the original reason I started taking photographs of basketball games and my other three beats—Campus Security, the golf team, and the baseball team. I also shot a lot of football photos. Even when my stories weren't published, the *Reveille* used some of my photographs, especially of basketball. That's how what started out as a quest for a higher grade resulted in a friendship with Pete.

Let me quickly add here that Pete and I were friends, but certainly not bosom buddies. If you hear anyone say they were intimate friends with Pete Maravich, be skeptical. In my experience, Pete was not particularly close to anyone, with the possible exception of his father, a few teammates, and Assistant Coach Jay McCreary.

The reason Pete was distant from most everyone is natural. After his fame began, I think Pete was wary of anyone trying to be too friendly. This was probably because he couldn't be certain who wanted to be his friend for ego purposes versus who would have been a friend no matter who Pete was. I believe our ROTC acquaintance before he hit the front pages gave Pete some assurance that I wasn't around to build up my ego when our friendship developed because of my journalism curriculum.

Over my college years, I shot hundreds of photographs during Pete's games. By necessity, all were home games because, as a poor college student, I simply could not travel to away games. Very few of my photographs have ever been published—or even seen—outside of what was in the *Reveille*. And only a few people know that I even have such a collection. Several close friends strongly urged me for years to publish these photos in a book, but I could never bring myself to seriously consider it. I believe that most people were around Pete in those days because he was a star and they could exploit that position for ego or gain. I guess I wanted to positively show that was not the case with me. It was a loyalty to our friendship. This feeling became even stronger after his death in 1988.

Why publish this book now? Well, it began with a garage sale that my wife Cheryl and I went to one Saturday morning in 1998. On one of the tables was a VHS tape called *Maravich Memories* (copyright 1988 by LA Production Group, Inc., Baton Rouge, LA). When I saw it, I told Cheryl, "I'm buying this tape because I want to show you that every time Pete came down the court, I was sitting under the goal taking pictures." Cheryl did not know Pete and had only heard a few of my stories about those days. I don't think she had seen but a very few of my photographs of Pete in action.

At home later that day, I popped the tape into the VCR machine and started watching. Sure enough, I could point myself out to Cheryl under the goal in almost every clip. After a few minutes, Cheryl left the room and went about her business. However, I continued to watch the video. Slowly, it struck me. I had forgotten how *good* Pete really was. Watching that tape brought back a lot of memories. I was astonished that I had forgotten so much about his unbelievable talents. It was then that my collection of photographs came to mind. After thirty years, I couldn't remember if they really captured Pete's extraordinary talents. I got them out of storage and went through the negatives. Yes, the negatives, in pristine shape, held some pretty good shots. But at this point, I still had no desire to publish a photo book on Pete.

My interest in doing a book grew a little more because of the following events. It was just a couple of years later that public interest in Pete began to increase. ESPN, CBS, and Turner Studios all did specials on Pete during the early years of the twenty-first century. The specials were usually broadcast during "March Madness," the college basketball play-offs.

One November afternoon in 2000, my phone rang and it was Kris Schwartz from ESPN. He told me that the sports network was doing a one-hour special on Pete Maravich and he understood from Ralph "Yuk" Jukkola (pronounced "Yook-a-la"), a teammate of Pete's and a friend of mine, that I had some photographs. I told him yes, but I had very few prints, only negatives. He asked if I could supply him with some photographs and ESPN would gladly pay for any that were used. I agreed, but my heart really wasn't in the venture. I hadn't had a personal darkroom for nearly thirty years. My thoughts were that if I sent ESPN any photos, I would have to do them personally so they would be cropped and printed according to my wishes.

I borrowed some equipment from a friend of mine and turned my bathroom into a darkroom one night. Boy, was I rusty. However, I did manage to run off some great prints of a few of the better photographs and sent them to ESPN. I believe they used eight in the show.

To my mind, the most memorable thing about the ESPN special was that it was predictable and remarkably ordinary. One segment really ticked me off. At one point, they interviewed Oscar Robertson, whose all-time college scoring record Pete broke in 1970. He made some condescending comment (and I'm paraphrasing) that Pete was okay, but really didn't understand the *science* (my emphasis) of basketball. My wife was startled when I immediately responded to the TV in a loud voice, "Well, he broke your record, idiot!" I really resented that comment.

In November of 2001, I received another phone call, this time from Black Canyon Productions in New York. The producer (I don't recall his name) talked with me extensively about Pete and the photos I had. He said they were doing a one-hour special for CBS to be broadcast during March Madness, 2002. During the conversation, I mentioned that I had written stories about Pete for the *Reveille*. To my astonishment, he told me he already knew that because he had on his desk a copy of every story I had written about LSU basketball. I replied that he had something I didn't have—a complete collection of my stories.

The producer asked not only for photographs, but for an on-camera interview with me in December. Unfortunately, I had to be out of town the week the company would be conducting interviews with people that knew Pete.

The show aired in March and was wonderful. The producers used a few of my photographs, but I especially liked the way they captured the change in Pete by highlighting certain photographs. In his college and professional days, Pete was a troubled person, as is well documented by Pete and others. His whole life was oriented to a championship ring. It was like the weight of the world was on his shoulders. I detected some of this when I was around him, but never could quite put my finger on what was troubling him. Some of it was family problems, which have also been documented by others. Of course, Pete later went through a

spiritual conversion and became extremely happy and content. That change clearly showed in the photographs used in the CBS special.

The third special I was involved with was a 2004 short production by Turner Studios. Producer Corey Stienecker called to tell me the company would be in town interviewing Ralph Jukkola and Josh Maravich, one of Pete's two sons, who at the time was playing on the LSU basketball team. He asked if I could meet with him about photographs and appear on camera when the show was taped in Baton Rouge. I agreed and taped my interview the same day as Yuk and Josh. After Josh was interviewed, I managed a few minutes with him to relate some of my personal memories of his dad that he probably had never heard—like the ROTC roll-call story. I think he appreciated that. All in all, the special was well done, and I enjoyed it. Turner Studios sent Yuk and me personal copies of the tape.

Now is a good time for an interesting side note to this taping. Turner Studios interviewed Yuk in the old John M. Parker Agricultural Coliseum (Parker Coliseum, for short), where LSU played basketball during Pete's years. Yuk and I have been good friends since college, but after his interview, Yuk told me something I never knew about his coming to LSU to play basketball. Off camera, Yuk pulled out a beautiful 8 × 10 glossy photograph of the interior of Parker Coliseum and stuck it in my hand. The photo shows the basketball court under the arena lights and makes the place look like Madison Square Garden. Yuk laughed and explained to me that he was recruited and came to LSU on the basis of that photograph. He said although he had visited the campus before he enrolled, he had not seen the inside of Parker Coliseum because an event (later he found out it was a rodeo) was going on at the time. However, he was shown the photo by Assistant Coach Jay McCreary, who explained, "That's what the basketball court looks like." Yuk said it wasn't until he actually came to LSU as a student that he found out Parker Coliseum was really a rodeo-type arena with a dirt floor and had the nickname "Cow Palace"!

For those who may not know, the basketball court in Parker Coliseum was a portable wooden floor installed each year for the basketball season. Yuk reminded me that the team had to practice elsewhere until sometime around Thanksgiving while the floor was being installed. In addition, the team always finished the last four or five games of the season on the road because the LSU Livestock Show began in mid-February and the basketball court had to be disassembled to reveal the dirt floor. I consoled Yuk with the story that Press Maravich told about his recruitment to be LSU coach. He said Assistant Coach McCreary was driving him around campus on a tour and they passed Parker Coliseum. Press asked what building that was and Coach McCreary replied, "Oh, that's the John M. Parker Agricultural Coliseum, where the basketball team plays its home games." Press said he never saw the inside until after he came to LSU as coach.

Yuk says there was one good thing about that portable floor. It had dead spots

in it. You could be dribbling along and hit one of the dead spots and the ball would practically die on the dribble. Of course the LSU players would generally know where these spots were and avoided them. The opposing team didn't know, and this gave LSU an advantage to try and steal the ball when the dribbler hit a dead spot.

I have more stories to relate, but this is not meant to be a "Pete and Danny" book. What I have come to realize is that publishing this photographic record is not exploiting Pete or our friendship. I now feel I am perhaps the only one who can provide such a record whereby readers can see for themselves what a great basketball player Pete was.

As I said earlier, I did not take photographs at all of Pete's games. And I did not take pictures at all home games. However, I have arranged the photographs of what games I have in the sequential order in which they were played. I have done my best to research each game and provide a synopsis of what occurred. Where I can, I provide some personal comments, but forgive me if after forty years some of the details have escaped me. One thing is for sure, you will see Pete Maravich at LSU as he has never been shown before.

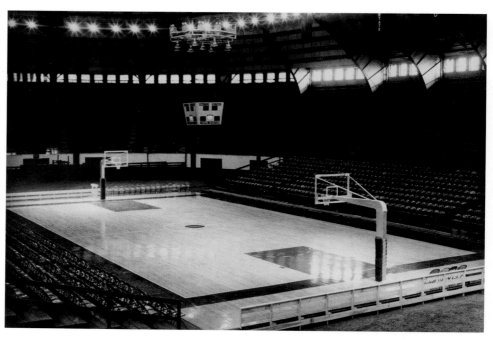

The John M. Parker Agricultural Coliseum looks like a super place to play basketball in this photo given to Ralph Jukkola when he was being recruited by LSU assistant coach Jay McCreary in 1965. If you look closely, however, you can see the dirt rodeo floor beyond the wooden railings on the lower right. The basketball court was constructed on a framework placed over the dirt floor.

Photo courtesy LSU Public Affairs

1
Pete's Sophomore Season

1967–1968

Let me say here that I have a good memory, but by no means can I quote you two or three years of game statistics off the top of my head. So, for this book I have had to reference the microfilm files of stories I wrote for the *Reveille,* as well as the microfilm files of newspaper accounts of the games.

In researching the Pete Maravich games I photographed, even I was surprised at some of the statistics and details of the games. And I freely admit that the information I found did bring back a lot of memories of events that I had forgotten. I can say it truly was magical reliving that time in my life. I just hope this book can give the reader some feel for the LSU basketball era of Pete Maravich. Without a doubt it was an era that will never be repeated.

The Clemson Game

January 24, 1968

I wish I could tell you that I remember something about the first LSU basketball game where I took photographs of Pete. However, I simply can't. You must realize that all of it started out as an adjunct to my journalism curriculum, where I had a chance to attain a higher grade if I had more inches published in the *Reveille*.

The 1968 spring semester had just started, and my class work required that I cover certain beats for the campus newspaper. In addition to Campus Security (LSU Police), the golf team, and the baseball team, I was given basketball. I am certain I was "given" these assignments because I would never have chosen them. Campus Security and the golf team were dead subjects that produced almost no published inches, and baseball didn't get underway until about the time basketball season ended. That left basketball. I can honestly say that I was now more interested in basketball than before because of the publicity that Pete was bringing to LSU's team.

According to the negative files I have, the first season basketball game I photographed was the Clemson game played on January 24, 1968. It was the 13th game of the season (out of a 26-game schedule). You can readily see that half the season was gone before I attended my first game. Like I said, basketball was not my sport, and I probably wouldn't have been there except for my pursuit of a better class grade.

Records say that LSU won the game 104–81. Although I have no memories of the game, I can say that most of my 61 negatives are properly exposed and developed, and contain some good action shots. From newspaper accounts, I know that Pete fouled out with 12:27 left in the game. He had "only" 33 points. The victory gave LSU a 10–3 record, a far

..................

Taken on November 22, 1967, this is a photo of Press and Pete prior to the start of Pete's sophomore season. Just into journalism school, I had tagged along with an upper classman covering the team photo session for the *Reveille*. Notice that Pete came in "formal attire"—that is, without those floppy lucky socks.

cry better than the 3–23 season the varsity team had the year before Pete moved up from the freshman team.

Someone, and I don't remember who, told me a statistic of the 3–23 team that was astounding. In one of their games, the Tigers came down the court 13 or 14 times in a row and not only didn't score, but *didn't get a shot off!* Now that's horrible. You can see why a 10–3 record at this point was beginning to fill Parker Coliseum to near its approximate 10,000 capacity.

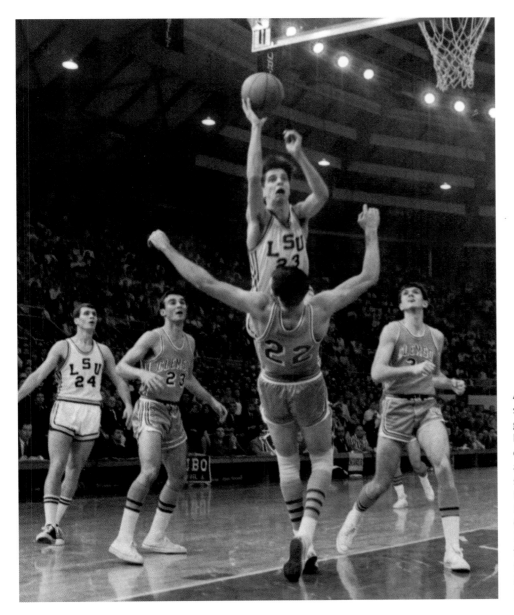

Against Clemson, Pete shows his typical aggressive charge to the basket. Later in his career, Pete often got away with aggressive shots that could easily have been called charging. However, in the Clemson game, Pete learned the hard way that the referees would sometimes call it tight. He fouled out with 12:27 left in the game.

When Pete was leading the freshman team to a 17–1 record the year before, some 3,000 to 5,000 fans would show up to watch the freshmen play just before the varsity took the court. When the freshman game was over, only about 500 to maybe 1,000 spectators would stay to watch the varsity. It was a sad but accurate reflection on the quality of the varsity team that year. At one point, Press Maravich is reported to have said he sometimes wished the freshmen played their game *after* the varsity so the crowd would stay.

According to the newspaper accounts, the officiating in the Clemson game

Pete could hang in the air for what seemed an eternity. I think one of the secrets was the height he obtained. In this shot, he is clearly higher than LSU's 6'8" Randy Lamont (43). It illustrates perfectly the uncanny ability he had to just "float" there for the longest time while deciding what to do with the basketball.

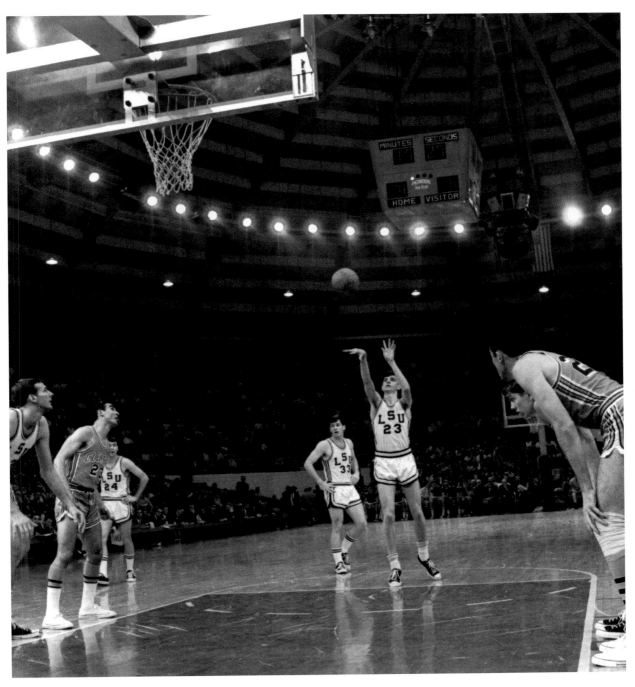

Pete had perfect foul shot form. It was like watching a machine. His 3-year varsity-career percentage of made free throws was 77.5 percent. In the Clemson game, he made five of six free throws and scored 33 points before fouling out.

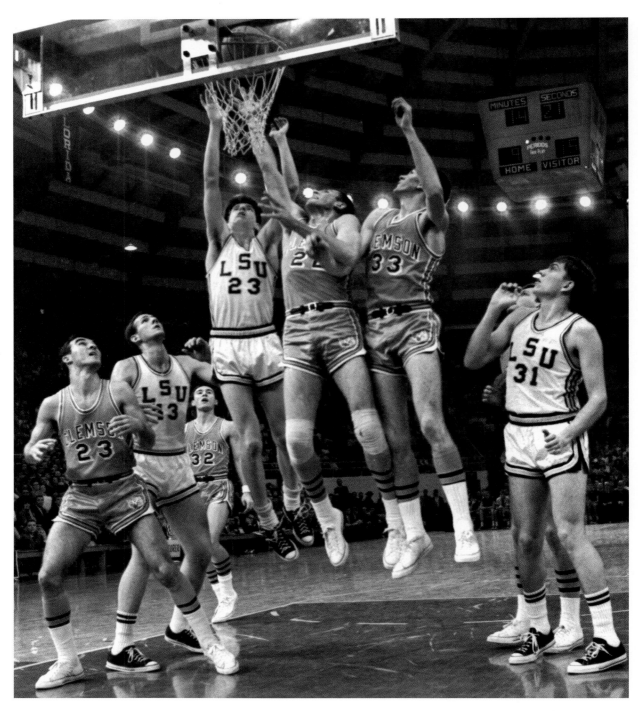

Pete was good at hitting the offensive boards for rebounds. In the Clemson game, LSU hit on 42 of 83 shots for 50.6 percent. Pete put several of his offensive rebounds back in for scores, which contributed to his personal 48.3 percentage (14 of 29).

was atrocious. The call that fouled out Pete was questionable, and the Tiger fans raised the roof with noise for several minutes, peppering the floor with paper cups, ice, and other debris. This brought on a technical foul, which caused even more noise. Even Clemson coach Bobby Roberts got irate at the referees. He went at it nose to nose with one of the officials for about two minutes near the end of the game. That confrontation is among the photos I have. The referee had called a Clemson player for fouling LSU's Rusty Bergman. The call resulted in four points for the Tigers—two from the field goal Bergman made on the foul and two more from free throws he made as a result of the foul. All in all, it must have been an exciting game. I only wish that I could remember it. But at least the negatives prove that my body was there, if not my memory.

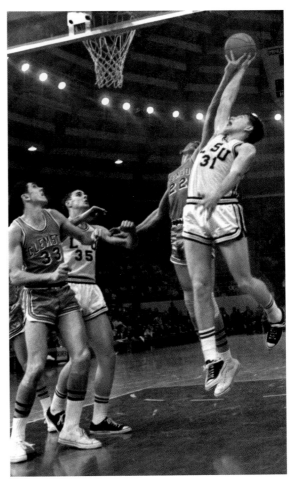

Ralph Jukkola (31) "skies" for an offensive rebound against Clemson. A standing joke between Yuk and me over the years has been his leaping ability. I would often tell him that I got a great photo of him going for a rebound and that he must be "that high off the floor." My hands would be about six inches apart. This photo proves Yuk could do a lot better.

With 1:17 left in the game, Clemson coach Bobby Roberts came off the bench to violently argue a call by the referee. To the amusement of Tiger fans, Roberts stayed in the face of the referee and followed him in circles while arguing. The scene was given a roaring ovation.

The Tennessee Game

February 5, 1968

The next game for which I have negatives is the Tennessee game, the 17th game of the season, played on February 5, 1968. At the time, Tennessee was in first place in the Southeastern Conference (SEC), and LSU lost by 20 points, 87–67. This gave the Volunteers a 15–2 record overall and 9–1 in SEC play. On the other hand, this was the Tigers' fourth straight loss, all in SEC play, and ran their season record to 10–7. It also was the lowest point total so far on the season for LSU (67), and it was also the lowest for Pete at 21 points.

Oddly, I do remember a couple of things about this game. One is a photo I took of Pete standing next to Tennessee's 7 ft., 270 lb. Tom Boerwinkle, both with their backs to the camera. I remember the photo because Pete looked kind of short, even at 6'5", while standing next to Boerwinkle. The two were along the foul lane waiting for someone to take a foul shot. What I like about this photo is Ralph "Yuk" Jukkola on the other side of the foul lane looking back at Pete. He has this odd expression on his face, almost as if he were saying to Pete mentally, "Do you really think you can outjump that gorilla standing next to you?" I actually saw that picture before I took it. In fact, I took two photos—one a horizontal shot and one a vertical. The vertical shot is super. It was a good picture when I saw it in the viewfinder, and it is still a good print on paper.

Like I said, Yuk is a friend, and we've talked a lot of basketball over the years. Yuk reminded me once that he had to guard Boerwinkle much of the time during the Tennessee games. "It was rough getting elbowed

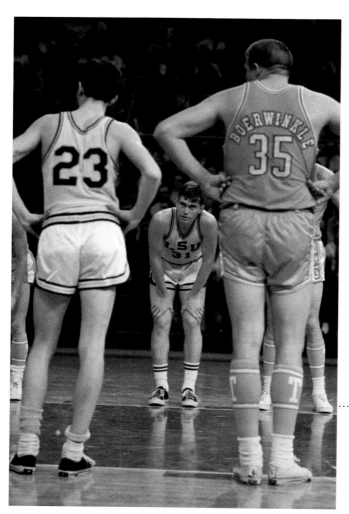

This is one of my favorite photographs. Tennessee's 7' tall, 270 lb. Tom Boerwinkle stands next to a seemingly short (6'5") and skinny (175 lb.) Pete while awaiting a foul shot. The size differential is apparent. From across the foul lane, Ralph Jukkola (31) fixes Pete with an odd stare. The photo tells the exact story I saw with the camera and wanted to capture on film.

and pushed around by the big man," Yuk says, "but I also got in a few shoves and elbows." Years later, Yuk says he met Boerwinkle at a function in New Orleans and they talked basketball. Yuk asked if Boerwinkle remembered playing against him at LSU. The reply was that he did, but Yuk didn't really believe him. "I was just another body to elbow and shove on the court. But at least he was polite in pretending to remember," Yuk says.

The other thing I recall about this Tennessee game is the frustration I felt at getting beat again and looking so bad. LSU was as cold as ice. The Tigers couldn't hit anything, not even foul shots. I distinctly remember thinking, "Someday, LSU is going to beat some of the big guys [teams] like this." I was beginning to become a true LSU basketball fan. I think it had something to do with the Tigers' underdog status. I really wanted them to be better.

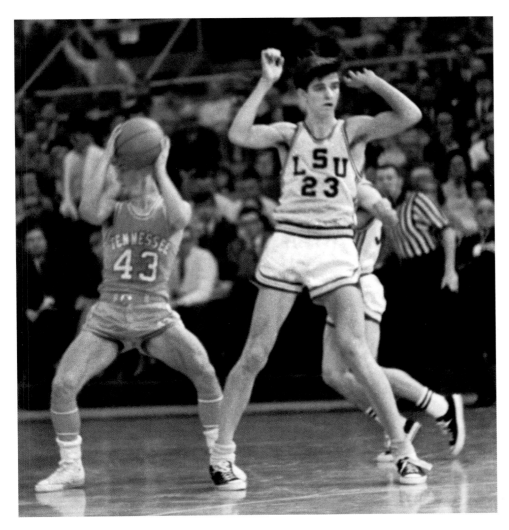

Taken on the LSU end of the court, this photo shows Pete as he had just lost a loose ball to Tennessee. He seems to be attempting to convince the referee that he was fouled on the play, but no foul was called. Tennessee's defense held Pete to 21 points, far below his 45.1 per-game average at the time.

By the way, the attendance at that game was listed as 8,300. Parker Coliseum wasn't full to capacity, but some games were sold out and had more than 9,300 in attendance. That was a far cry from the 500 to 1,000 spectators that would show up for varsity games the previous year.

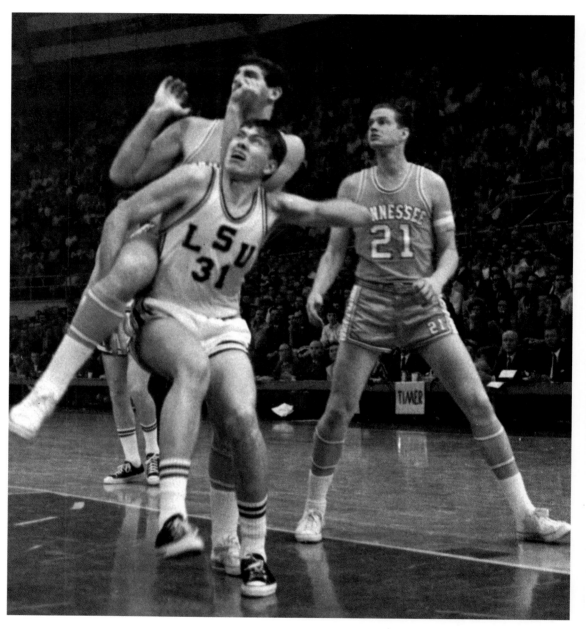

Ralph Jukkola (31) was LSU's top rebounder for the 1966–67 and 1967–68 seasons. I think you can see that one of the reasons was his "unique technique" of keeping the other team's players from "getting a leg up," so to speak. However, in this game, the Volunteers out-rebounded LSU 47–35.

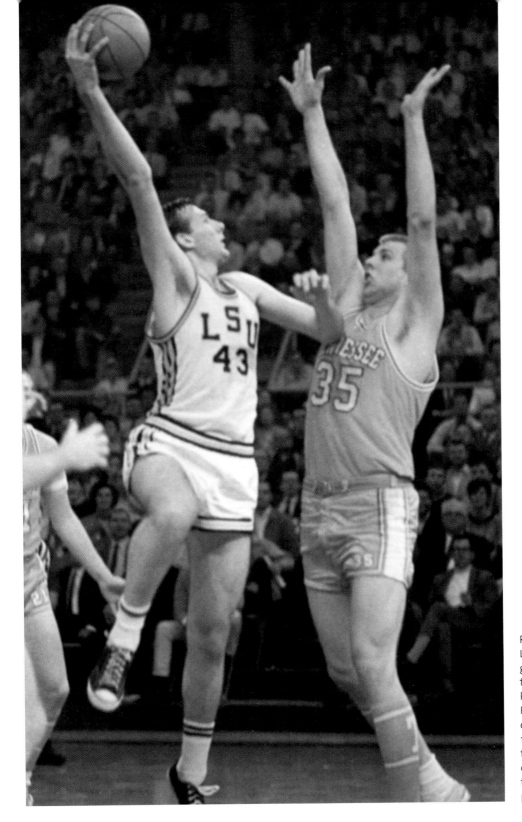

Randy Lamont (43) kept LSU in the Tennessee game with shots like this over Tom Boerwinkle's outstretched arms. Randy had 20 points on five field goals and 10 of 11 from the free-throw line. LSU made only 25 of 70 shots in this dismal game, a 35.7 percent average.

The Florida Game

February 10, 1968

My wish to beat one of the big boys in a game came true faster than I would have ever believed. Boy, how I remember this game. Just five days after the Tennessee game, LSU upset Florida 93–92 in overtime, on February 10, 1968. The star of the game was the smallest guy on either team—Rich "Killer" Lupcho. (The program listed him at 5'8", but that was too generous by 2 or 3 inches.) "Killer" was a nickname LSU assistant coach Jay McCreary had pinned on the diminutive Lupcho. He had scored only 31 points in 18 games, but he sank a free throw with 15 seconds left in overtime to give LSU a three-point lead. Florida managed only one field goal before time ran out. I remember seeing Ralph Jukkola help hoist "Lup" up on his shoulders when the game ended. I got photos of the foul shot and one of Lup on the shoulders of his teammates. It was a sweet victory.

This was the 19th game of the season for LSU. Before the game, LSU was 5–6 in the SEC and 10–8 overall. Florida was 11–3 in the SEC and in the thick of the race for the conference title. In addition, Florida had beaten LSU in the first conference game of the season and started the Tigers on their losing trend in the SEC. This upset loss all but ended Florida's hope for the SEC title.

Both teams had their star players. LSU had Pete Maravich and Florida had 6'11" Neal Walk. Walk scored 38 points in the game and had 19 rebounds, enough to keep him in the top 10 in the nation on both counts. He was hampered in the second half with foul trouble, but managed to stay in for the entire game. The nation's leading scorer by now, Pete scored 47 points and had seven rebounds. This was slightly above his 44 point average. Yuk had 12 points and seven rebounds, while LSU's Rich Hickman had 22 points, third behind only Pete and Walk.

One other thing I remember about the game was the photo I took at half-time of the presentation of a golden basketball to Pete by 1950s LSU All-American Bob Pettit. Pettit was at the game as a TV announcer for the TVS network. Pete had broken Pettit's SEC scoring record for one season with the Auburn game the previous Wednesday. In presenting the ball to Pete, Pettit noted that every point Pete would make until the end of the season would be a new SEC season scoring record.

A really funny event involving Lup and Yuk occurred after the game. As I said, Yuk was one of the players lifting Lup on his shoulders amid the victory celebration. On the floor again, Lup was busy signing autographs and accepting the adoration of fans. Out of the crowd came this hand with a program in it, which Lup took and hurriedly signed. When he looked up, it was Yuk standing there with the program, laughing and telling Lup, "Thanks for the autograph."

By this time in the season, I was becoming a familiar face around Press's

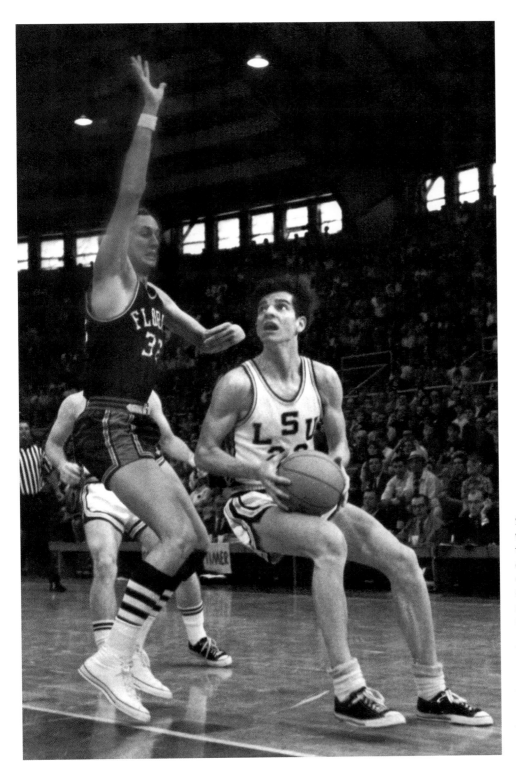

Stopping on a dime was one of Pete's great talents. Often, he would dribble around the offensive end of the court before stopping suddenly with a head-and-arms motion that looked like he was going to shoot. The defensive player would leap to block a shot that wasn't there. Pete would then follow with his classic jump shot over the out-of-position defensive player.

office. I was there a lot trying to find any angle I could to lengthen my stories or to find a subject for a side story that might increase my published inches in the *Reveille*. Pete was usually hanging around his dad's office, so he and I began to talk more and more on a friendship level. I definitely feel that Pete was always sincere in his attempts to help me out. Sometimes our conversations drifted away from LSU basketball to other teams and players, and to subjects not related to basketball at all. I distinctly remember kidding him more than once about

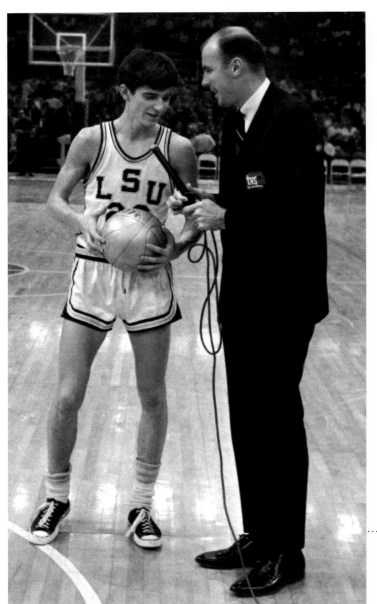

numerous absences from ROTC drills when he was a freshman. His reply was a grin and some kind of answer like, "You know I had basketball practice." I would say something like, "Yeah, practice. I know." It was probably true, but like everyone else, I'm sure he hated being forced to go through ROTC and its marching drills.

I was also becoming a familiar face around the LSU Sports Information Office, which was then headed up by Bud Johnson. Johnson and his office always acceded to my requests for photography passes to the basketball and baseball games, no matter what the demand was from the outside media. As a courtesy, I would usually give them a few of my prints. For this reason, I occasionally still see some of my photographs show up in books or other publications and credited to the LSU Sports Information Office. I don't mind, though. I'm flattered that the photos are still used.

Former LSU great Bob Pettit presents Pete with a golden basketball at half-time of the Florida game. In the Auburn game a few days earlier, Pete had broken Pettit's SEC season scoring record set in the early 1950s.

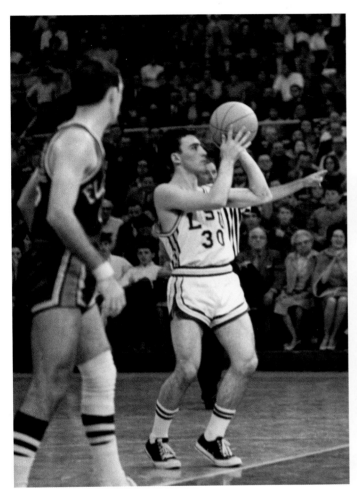

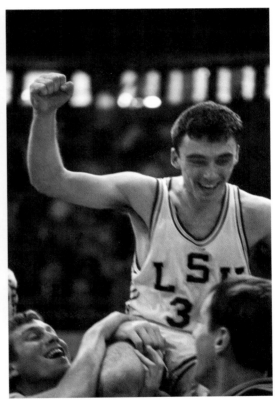

Rich "Killer" Lupcho (30) takes aim on a foul shot with 15 seconds remaining in overtime of the Florida game. The shot gave LSU a three-point lead, which proved to be the winning margin in a huge 93–92 upset win over Florida. Notice the woman sitting in the stands on the right who looks like she is praying. That's exactly what I and all LSU fans in attendance were doing. By the way, Lup sank only two of five foul shots in scoring his two-point game total. The winning shot was one of the two.

Lupcho raises his fist in victory as teammates hoist him on their shoulders after the Florida victory. Lup would prove to be the bane of Florida again the next year as his small stature would be responsible for fouling out Florida's star player, Neal Walk. LSU would also win that game in overtime, 93–89.

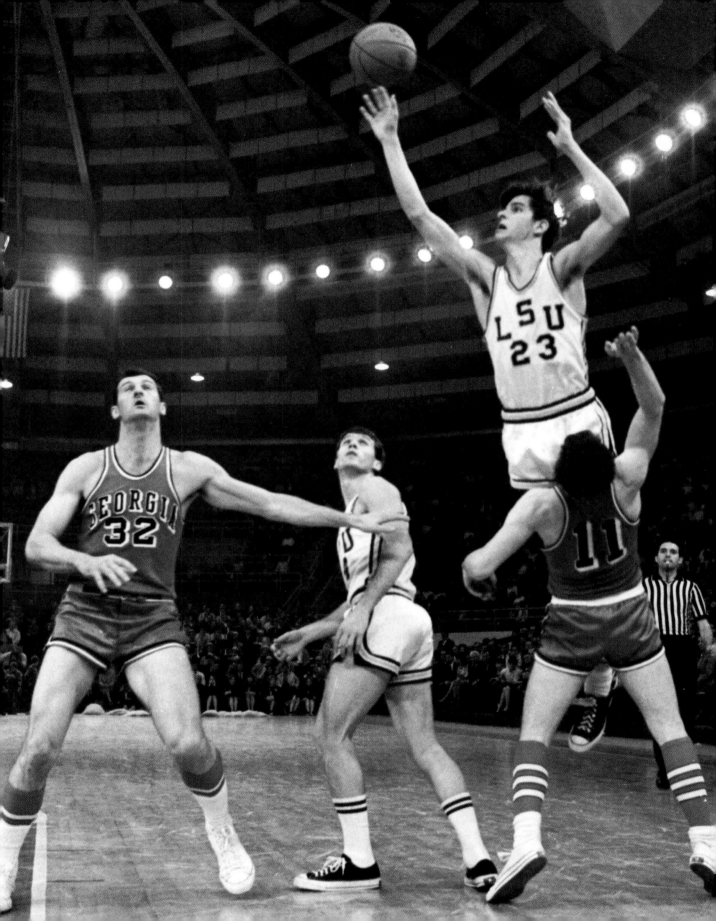

The Georgia Game

February 12, 1968

After the Florida upset on Saturday, everyone felt the Tigers were beginning to roll, and that this Monday night game two days later would be more of the same. To add to that feeling, LSU had already beaten Georgia 79–76 in Athens earlier in the season. The home court advantage of this game practically guaranteed that LSU would win again. It was not to be. The 20th game of the season was a disappointing and heartbreaking 78–73 loss to Georgia.

Georgia played a very deliberate type of offense. Add to that the fact that the Bulldogs' five starting players were in for practically the entire game, and you can see why the results were double-digit scoring for four of them. And the fifth man was just one point away at nine points. The big man for Georgia was 6'11" Bob Lienhard, who hailed from the Bronx. He poured in 28 points and had 21 rebounds.

The loss was heartbreaking for several reasons. Although Pete had 51 points, he had one of his worst nights at the foul line, hitting only 11 of 18. Indeed, the whole team had a bad night from the free throw line, hitting only 13 of 25. And then there were the overall shooting percentages and the overall rebounding categories. Georgia led in both, shooting a hot 50.8 percent to LSU's 43.5 percent, and out-rebounding LSU 51–39.

Still, LSU came very close. After being down 43–34 in the first half, the Tigers staged a furious comeback in the second half. With 13:45 left in the game, Pete went on a scoring rampage. He dropped in eight straight field goals in four minutes and 36 seconds and cut the margin to one point at 60–59. Georgia's lead was 75–73 with less than a minute to play when Pete very uncharacteristically missed a driving layup. After that, LSU had to foul to get possession of the ball and Georgia sank three free throws to win the game.

The loss put LSU's overall season record at 11–9, and 6–7 in the SEC.

.......................

No, this is not a charging foul. It is part of Pete's one-man charge in the second half of the Georgia game. He made eight straight field goals in four minutes and 36 seconds to move the Tigers to within a point of Georgia.

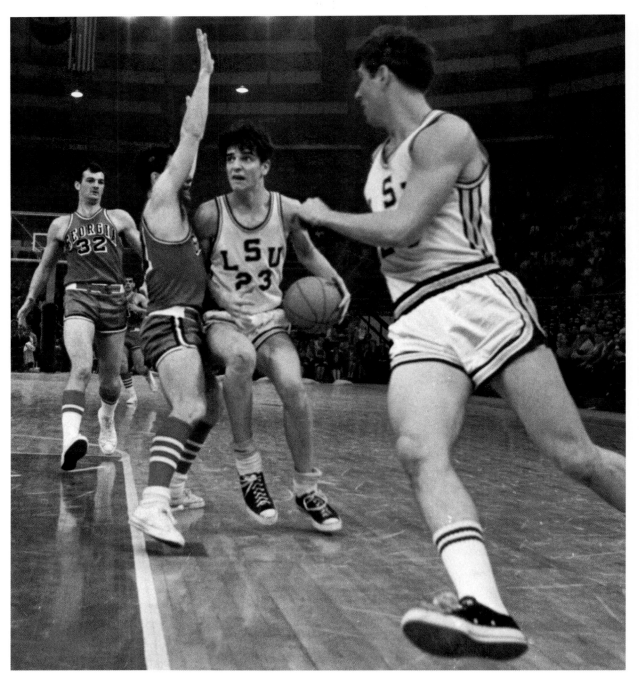

The Georgia player here is able to block the completion of a fast-break by Pete. Pete simply pulled up and passed the ball to Rusty Bergman for an easy layup.

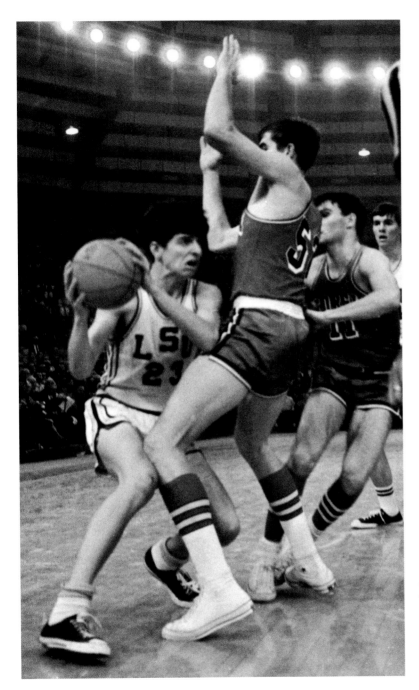

Georgia's Bob Lienhard (54) was a pretty formidable obstacle for Pete in the Georgia game. The big man effectively blocked Pete's baseline drive on this play, forcing him to look for help from his teammates. Notice the second Georgia player coming in to double-team Pete.

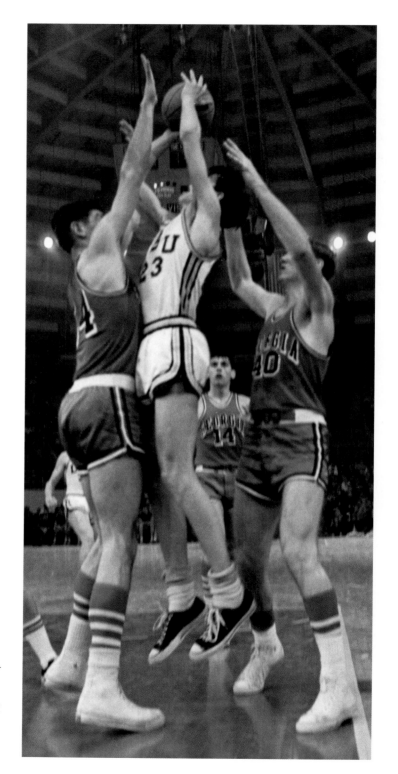

Pete was never afraid to challenge 6'11" Lienhard. Pete managed to draw a lot of fouls from the Georgia players, but had one of his worst games at the foul line (11–18). Despite this, Pete scored 51 points in the 78–73 loss to Georgia.

The Tulane Game

February 21, 1968

I remember this game well. It was the 23rd game of the season, and a win would give LSU a 14–9 record. It would also assure the Tigers of their first winning season since 1961–62. More important, Pete had 984 points on the season coming into the game, and if he could score 16 points, he would be the country's first college sophomore ever to score 1,000 points. Parker Coliseum was packed in anticipation. The crowd was not disappointed as LSU won 99–92 and Pete got 55 points to surpass the 1,000 mark.

Leading up to the record-breaking shot, the fans sat in rapt anticipation. Pete's point total slowly crept toward the magic number a little more than halfway through the first half. The crowd oohed and aahed as he missed several short jump shots when he was only two points from the record. Then it happened. Pete got the ball on a fast-break, dribbled down the court, and scored an easy layup

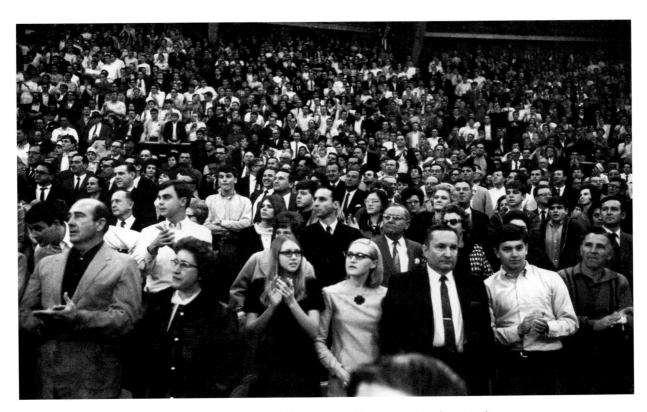

There was high tension and electric anticipation at the Tulane game. Not only was it a huge rivalry game against a very good opponent, but Pete was going for his 1,000th point—a first for a college player in his sophomore year.

with 8:37 left in the first half. The crowd erupted in cheers and applause. The referee stopped the game with an official time-out and gave the ball to Press. Press then presented the ball to Pete, and they shook hands.

This was the last game I photographed that season because the team played its last three games on the road at Ole Miss, Tennessee, and Vanderbilt. The Tigers lost all three and finished 14–12. That may not sound impressive until you remember the previous year's team and the sparse attendance. The awards were rolling in for Pete, and the legend had begun. Even I was sold on basketball.

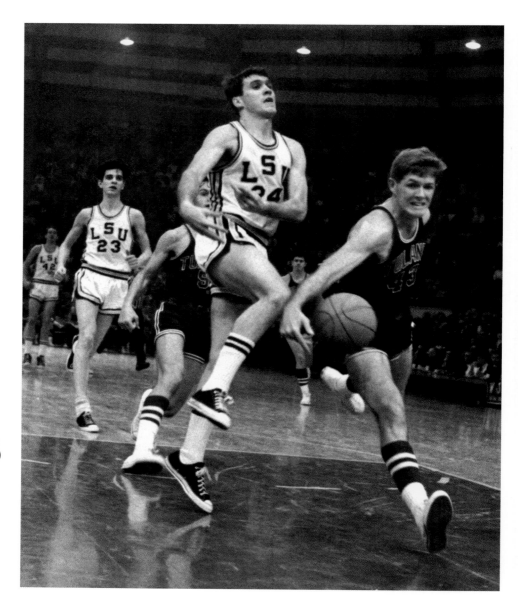

Tulane's Terry Habig (43) strips the ball from LSU's Rich Hickman (24) on this fast-break play, preventing a sure two points. Pete trails the play after passing the ball to Rich. Although Rich scored 14 points in the game, he got no points on this play as a foul was not called.

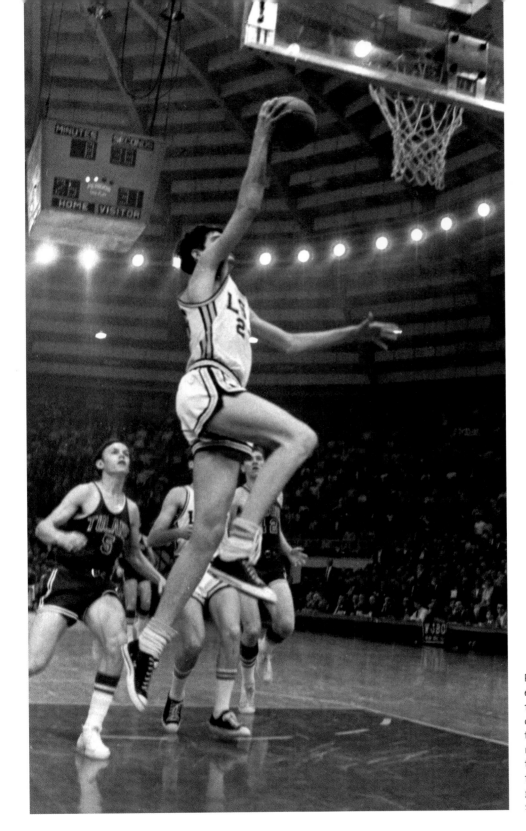

Pete has an open and easy layup for his 1,000th point. The play came with 8:37 left in the first half. For the rest of the season, every time Pete attempted a field goal, made a field goal, or had an assist, he set a new LSU record.

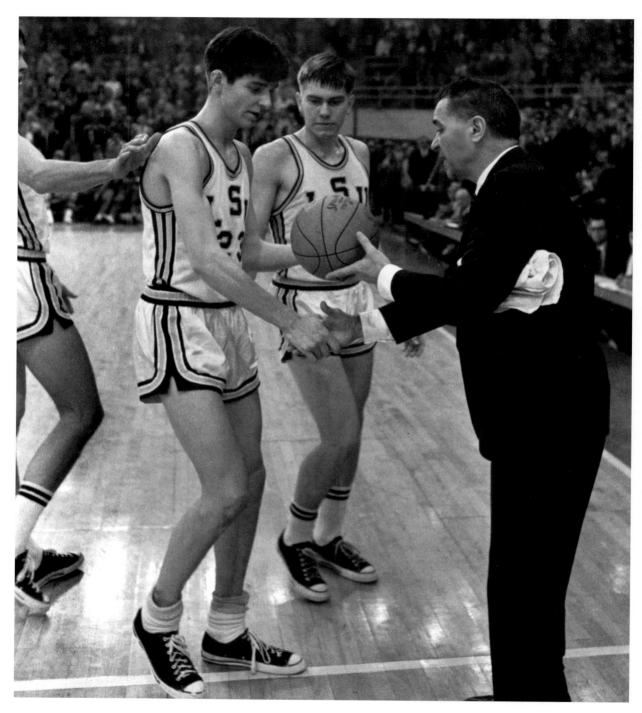

After Pete scored his 1,000th point, the officials called a time-out. Here Press formally presents Pete with the basketball used to break the record and shakes hands with him. That's Ralph Jukkola looking on.

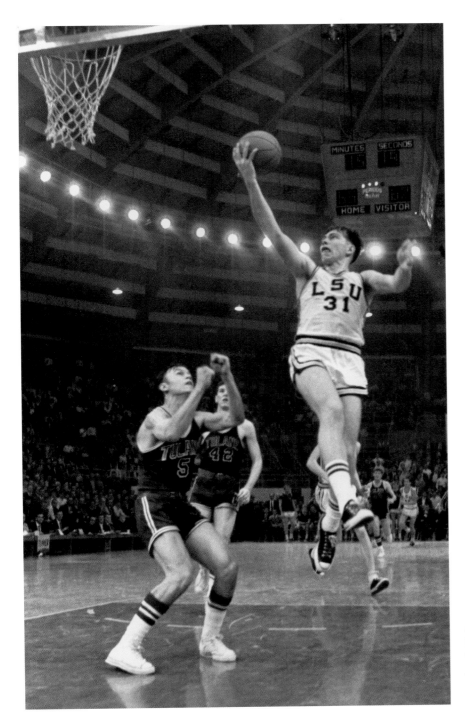

Although this looks like a rebound, Ralph Jukkola (31) is really going in for an easy layup on a fast-break. After Pete, Yuk was the next-highest scorer in the Tulane game with 17 points.

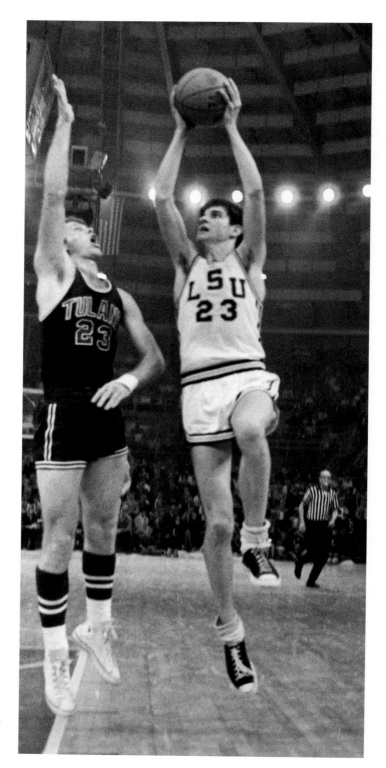

This is the classic two-handed shot Pete used when close to the goal. It seemed to be a cross between a hook shot, a jump shot, and a layup.

The Olympic Travesty

April 4–6, 1968

I would be remiss if I didn't mention the circumstances surrounding Pete being left off the 1968 Olympic basketball team. Just as his sophomore season ended in late February 1968, Pete was named to the Newspaper Enterprise Association (NEA) All-American team along with Elvin Hayes of Houston, Lew Alcindor (now known as Kareem Abdul-Jabbar) of UCLA, West Unseld of Louisville, and Don May of Dayton. The NEA team was chosen by the coaches and scouts of the National Basketball Association (NBA) and was a prestigious selection for any player, let alone a sophomore.

At the same time, Pete was also unanimously named to the All-SEC team by the Associated Press All-American Advisory Board. Then the United States Olympic Committee announced its selection of Pete as one of 88 players that would try out for one of the 12 positions on the 1968 U.S. Olympic basketball team.

After the announcement, I immediately called Pete and said I needed an interview for the *Reveille*. He agreed, and we met in Press's office that afternoon. I remember so clearly just how excited and upbeat he was about the Olympic trials opportunity. Of course, my first question was how he felt about it. "Great!" he answered, in an obviously happy voice. He quickly added that the Olympics had been in the back of his mind, but since they were played every four years, he was afraid that they would come up at a time when "one thing or another" would keep him from having a chance to participate.

Press pointed out that representing one's country in international competition was an honor few athletes have. When I asked whether the Olympics would interfere with next season's basketball schedule, Press told me that LSU would start practice on October 15, but the Olympics would end on October 23. "Pete will miss only one week of practice," he explained, "and the first game of the season will not be until December." I noted Press's use of the word *will*.

The word *will* was okay with me because we all "knew" Pete was a shoe-in to make the team. After all, he was the nation's leading scorer with a 43.8 average and was the first sophomore ever to score 1,000 points in a season. The three of us talked for quite a while, and we had Pete practically signed, sealed, and named to the team by the time I left Press's office.

But there were some things we hadn't considered—the personal politics, the plain stupidity of the 45-man Olympic committee who selected the team, the type of coaches selected to work with the trial teams, and the coach named to lead the Olympic team itself.

At the trials in Albuquerque, New Mexico, Pete played on the 10-man team of

former professional player and later Golden State Warriors coach Johnny Bach. Bach had a slow, methodical style of play that didn't really give Pete a chance to impress the selection committee, or anyone else for that matter. In one game, Bach played Pete only 9 minutes and 28 seconds, all in the first half.

And then there was Oklahoma State coach Henry B. "Hank" Iba, who had been chosen as head coach of the Olympic team. He was a tough coach with a deliberate brand of basketball that didn't favor high scorers. He had previously coached the 1964 U.S. Olympic basketball team to a first-place gold medal.

The whole selection process that year was, in my opinion, a travesty. No member of the UCLA national championship team, among them Lew Alcindor, made the cut. In addition, Niagara's Calvin Murphy, who averaged 38.2 points per game that season, didn't make the team. Of the nation's 18 leading scorers who went to the Olympic trials in Albuquerque, only one, Bill Hosket of Ohio State, was selected. Even though Iba's 1968 U.S. Olympic team would go on to win the gold medal that year against Yugoslavia, it was little comfort to those of us who thought Pete should have been on the team.

The announcement of the Olympic team members was made on Sunday, April 7, 1968, a day after the trials ended. When Pete got back to campus, I called his room and commiserated with him while I took notes for a story. I could tell he was down, way down. Although he tried to rationalize and sound upbeat, it just didn't come through. I could tell this was as big a disappointment as losing a national championship game. I wrote a story for the *Reveille,* but it was never published. The university began the Easter break that week, and we didn't publish again until April 17. By that time the story was too old, and the editors killed it. I really don't remember much about what was in the story, but now I'm glad it didn't make it into print. It was not one of my favorite pieces for the *Reveille.*

2

Pete's Junior Season

1968–1969

After last year's winning season, the expectations for Tiger basketball in Pete's junior year were sky high. I already had plenty of inches published in the *Reveille* that fall because of my LSU football pictures, but I was still looking forward to the basketball season for two reasons. First, I knew it would really top off my senior year. I was going to apply for editor of the *Reveille* for the spring semester and figured my coverage of a terrific basketball season wouldn't hurt. Let me add a quick side note here. As it turned out, I lost the editor job to another senior by one vote. The university's Publications Committee had the responsibility of selecting the staff of the *Reveille* in those days. Oddly, there were *no* voting journalism professors or teachers on the committee. Looking back, I'm kind of glad the other guy was chosen. That's because the spring semester, as I remember it, was really on the dull side when it came to news.

The second reason I wanted to stay busy that winter was my mother. Only forty-eight years old, she was dying of cancer. I hit the books hard, worked part-time at one of the local TV stations (for a class), and worked a part-time job at the *Baton Rouge Morning Advocate*. I wanted to fill my time as much as possible to help ease the stress.

Pete knew about my mother's situation, but we never really discussed it. As I think back to those days, I realize that he was under just as much stress at home as me—if not more. Almost no one knew at the time about his mother having a serious problem with alcohol. I am now sure it was one of the things at the root of that sharp edge and aloofness I noticed from time to time. The basketball season that year was probably as much a diversion for Press and Pete as it was for me.

Covering most of the home basketball games for the *Reveille* really was a big plus in helping take my mind off things. I shot 11 home games before Mom died on February 24, 1969. I had prayed that she would live long enough to see me graduate that May. She had saved money from her very small salary

to help finance my first semester at LSU. But seeing me graduate was just not to be. For her sake, I can say I made straight A's my last year in school, was awarded the Charles P. Manship Scholarship in Journalism, and won first place in the photography category of the Southwest Journalism Congress, a competition among 11 different university journalism schools.

The Tulane Game

December 14, 1968

This was the third game of the season and LSU was already 2–0, with wins over Tampa at home and Texas on the road. A crowd of 9,000 filled Parker Coliseum with the anticipation of seeing Tulane become victim number three. LSU and Tulane were arch-rivals, and Press tried to remind everyone that the Green Wave was a very good team. I don't recall if I thought the warning was all "coach-speak" or that he was indeed serious. All I remember thinking was that we had beaten Tampa 97–81 and Texas 87–74 and this would be just as easy if Pete was hot.

Although Pete got 55 points, he was only 20 of 48 from the field, and Tulane won 101–99 in double-overtime. Tempers ran high during the game, and shortly before the end of regulation, some fisticuffs broke out (like I said, they were arch-rivals). With LSU behind 89–88 and 29 seconds left in regulation, Pete was fouled. This was his chance to win the game, but Pete missed the first free throw. Fortunately, he made the second to tie the game and send it into overtime.

In the first overtime, LSU and Tulane each scored four points and were tied going into the last minute. Again Pete had the ball and would go for the win. He killed most of the last minute before running the offense for a final shot. However, Tulane double-teamed him well and Pete failed to get off that last shot.

In the second overtime, the score was tied at 99 when Tulane committed an offensive foul against Jeff Tribbett with 52 seconds remaining. He missed his free throw, and Tulane won it on a final-seconds tip-in.

The one thing I remember well about this game was not the play, but my photography. My film was badly underexposed. I don't know what happened, but I had to "intensify" the negatives in order to get any decent prints. Intensifying negatives is treating them in a solution that adds density to the faint images on the negatives. The poor quality of the pictures may have had something to do with the fact that this was the first game I shot that season, but I believe everything was set correctly on the camera. Or I may have used old developer that didn't properly develop the film. All I know is I have some pretty good shots of the game, but the quality is lousy when compared to my shots of most other games.

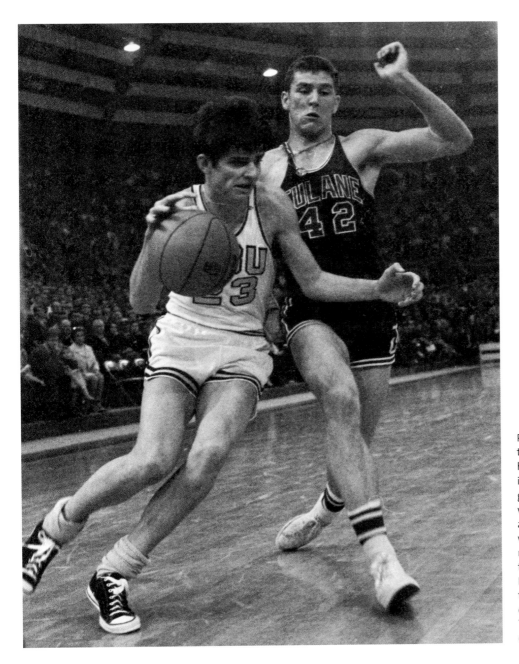

Pete made this move to drive the baseline hundreds of times during the games I photographed. The defenders would crowd, push off, and try to get in the way. Somehow, Pete managed to get around them most of the time. Pete scored 55 points in this Tulane game, but despite his effort the Tigers lost 101–99 in double-overtime.

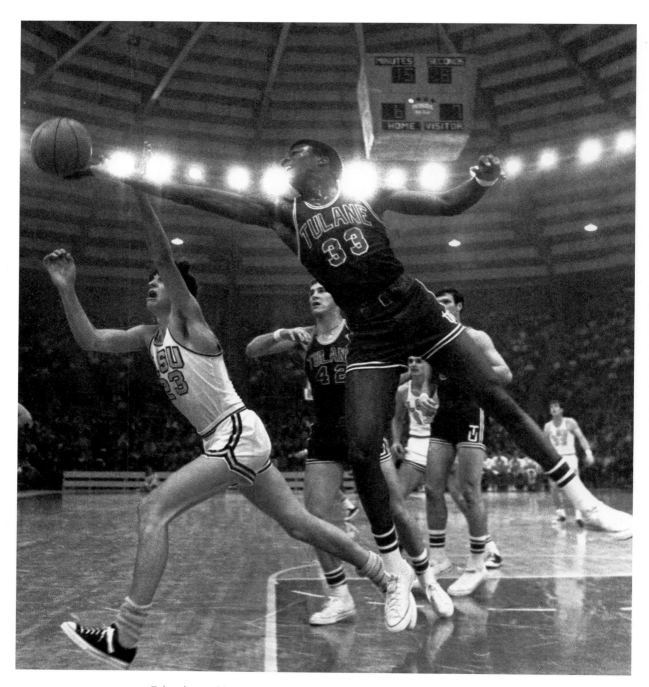

Tulane's Harold Sylvester (33) was a big thorn in LSU's side during the Tulane game. The sophomore from New Orleans' St. Augustine High School scored 32 points and—just as important—pulled down 22 rebounds. I don't remember who claimed this rebound, but the photo gives some idea of the reach Sylvester had that enabled him to get to the ball. Sylvester got the final rebound of the game to preserve the victory for Tulane.

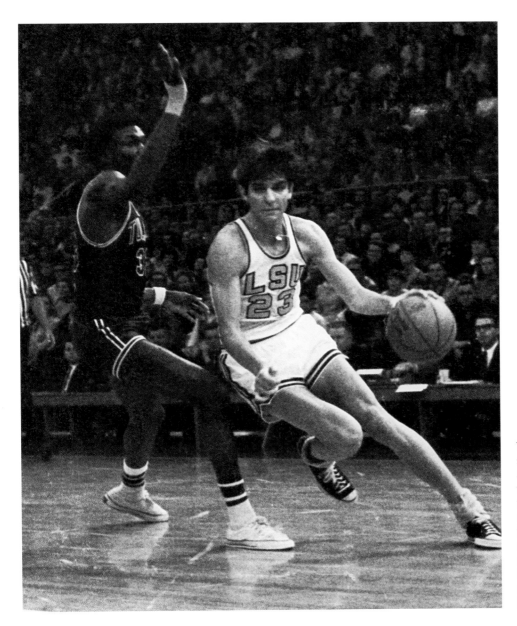

This photo gives you some idea of Pete's ambidextrous talent with a basketball. He was equally at ease driving the baseline from his left, dribbling with his left hand, as he was driving the baseline from his right and dribbling with his right hand.

The Florida Game

December 18, 1968

After that heartbreaking loss to Tulane, LSU opened SEC play with a 93–89 over-time victory against Florida. Played on December 18, 1968, it was only the fourth game of the season. Remember, too, that LSU had won last season's home game with Florida in overtime on Rich Lupcho's free throw. Again this was a tight game, but LSU led by a small margin most of the first half. Pete had 45 points, and Florida's Neal Walk had his usual good game with 34 points. Yet Walk fouled out as he made a goal that put Florida ahead 76–74 with 4:13 left in regulation. But the big story of that play was that "Killer" Lupcho again slew the giant.

Lup's buzz-saw defense was a pain in the side of Florida all night. However, it was his "hidden-in-plain-sight" presence that caused Walk to foul out. And the foul call produced a memorable scene. On his final foul, Walk practically stomped on little Lup after making his close-in field goal. The referee of course

called it immediately, and Walk began to pro-test repeatedly to the referee, "But I didn't see him!" That was probably true, but the referee only smiled and replied, "Well, it's still a foul," and Walk had to sit down. The LSU players and those in the crowd close enough to hear laughed and cheered the big man's demise. Ralph Jukkola later related the details of this event to me because although I could see what happened, I couldn't hear what was being said from my position at the opposite end of the court.

Lup's play turned out to be instrumental in this overtime win. Besides fouling out Walk, he made three of four crucial free throws, two valuable assists, and even had *two rebounds!* The little man was indeed the bane of Florida.

..................
After many tries in different games, I finally got this photo exactly as I wanted it. During time-outs, I could see what you see in this photo at times, but would always miss the exact composition I was trying to capture. During the Florida game, everything fell into place. Press is looking directly at Pete, and Assistant Coach Jay McCreary is also plainly visible.

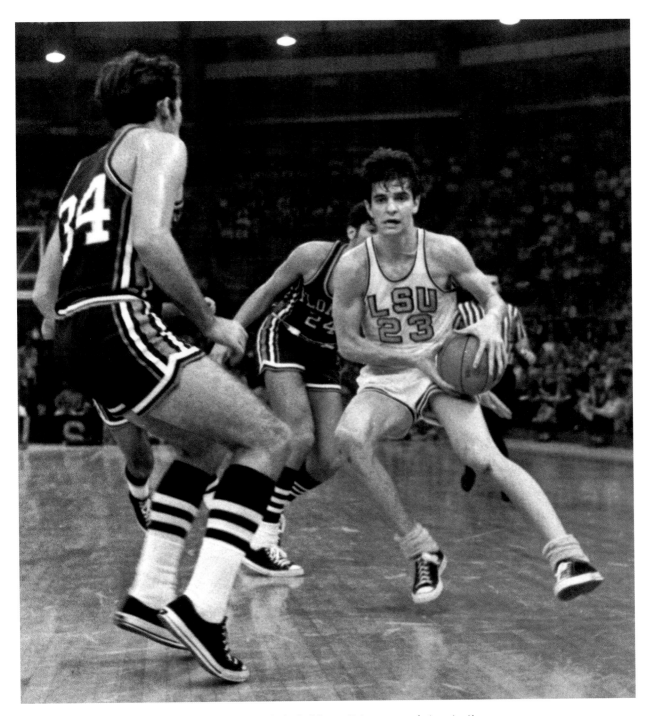

Notice the Florida player behind Pete trying to knock the ball loose. Pete was good at protecting the ball. He didn't have it stolen many times that I can remember. I think this photo really shows how he protected the ball by keeping it in close to his body.

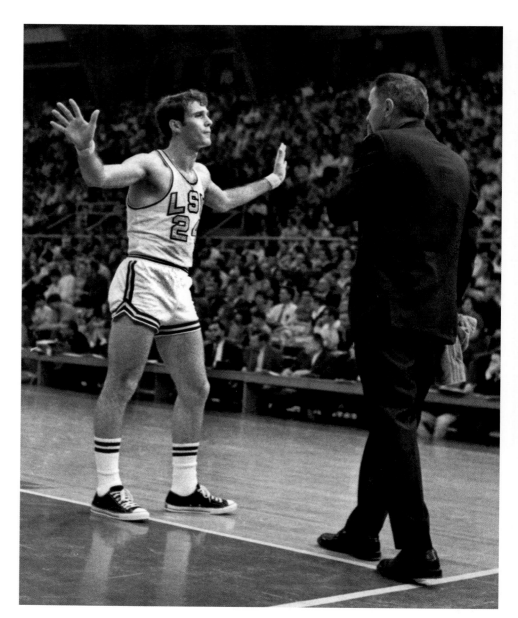

I don't remember exactly what Rich Hickman (24) was trying to explain to Press here, but I think it had something to do with one of LSU's 22 turnovers. At least Press looks to be listening with some sympathy. Rich scored 18 points in the Florida game, and was especially effective early in the game.

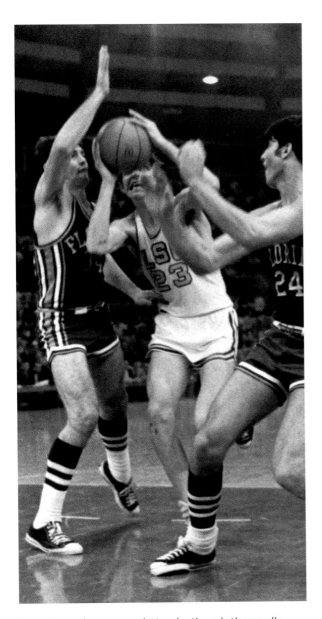

Pete always drew a crowd. Here he threads the needle toward the basket for two of his 45 points in the Florida game. The game was deadlocked at 83-all at the end of regulation, and Pete scored six of LSU's final 10 points in overtime as LSU won 93–89.

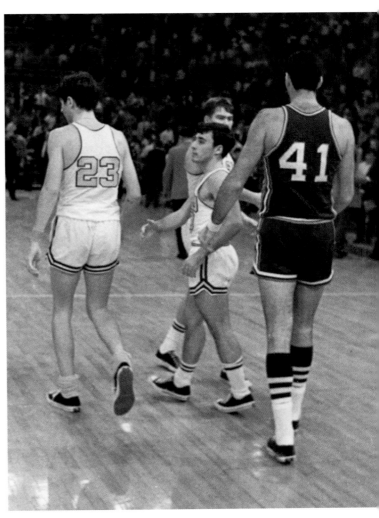

After the game, Florida's tall Neal Walk (41) shakes hands and offers congratulations to Rich Lupcho, who was responsible for fouling him out with 4:13 left in regulation. Fouling out Walk was huge for LSU as Walk had 34 points and a lot of Florida's 64 rebounds.

The Georgia Game

December 21, 1968

The Georgia game was the fifth of the season for LSU, played on December 21, 1968. It was the Tigers' fourth win in five games and their second in as many SEC games. Pete scored 47 points in a 98–89 victory that was somewhat of a redemption for last year's home loss to Georgia. In that game, Pete had missed a crucial layup with only 30 seconds left. At the time, LSU was down by only two points, and the miss probably cost LSU any chance of winning. For the remaining seconds of that game, LSU had to purposely foul in an attempt to get the ball back. Georgia's free throws made that losing score 78–73.

This year's game was also very exciting. Georgia's big man was again lanky 6'11" Bob Lienhard. He scored 29 points and helped Georgia out-rebound LSU 49–43. The game was tight all the way, but Tiger Dave Ramsden did a great job guarding Lienhard and contributed 12 points. In addition, Jeff Tribbett and Ralph Jukkola each scored 12 points, which put four LSU players in double digits.

There is one thing that sticks in my mind about this game, and it wasn't the play on the court. It was Pete in the dressing room after the game. Since I had covered only a few of the games the season before, it was the first time that I really saw the care he took with those droopy "lucky socks" he was famous for wearing. They were North Carolina State practice socks he got when Press was head coach there before coming to LSU. Pete really

Sometimes Pete ran out of room on the baseline drives. Here he balances on one foot looking for someone to help him before he goes out of bounds during the Georgia game. LSU won the game 98–89 by playing brilliant basketball, especially in the first and last 10 minutes of the game.

liked those socks because they were extra long and comfortable. After a while, he became a little superstitious about them.

That night in the dressing room, I happened to be standing nearby when he took off those socks. It was then I noticed how he set them to the side, separate from the dirty-uniforms laundry. Nearly everyone had heard about or seen those lucky socks. However, this was the first time I realized that Pete washed those socks himself, usually before leaving the dressing room after the game. Because their loss by accident or theft would have been a calamity of gigantic proportions to Pete, he never entrusted the socks to the team laundry.

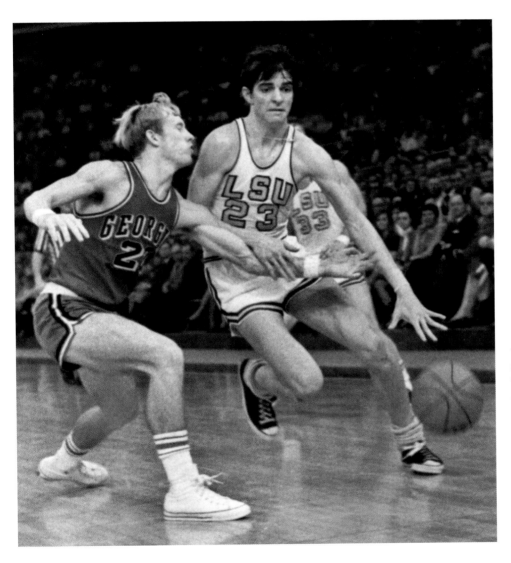

This photo illustrates a sure way to keep a rival from stealing the ball on a dribble. Pete shoves away the arm of Georgia's Lanny Taylor (22) as he reaches in for the steal. Another reason it was so hard to steal a ball from Pete was his very low dribble, noticeable in this picture. It was typical of Pete when he got in close.

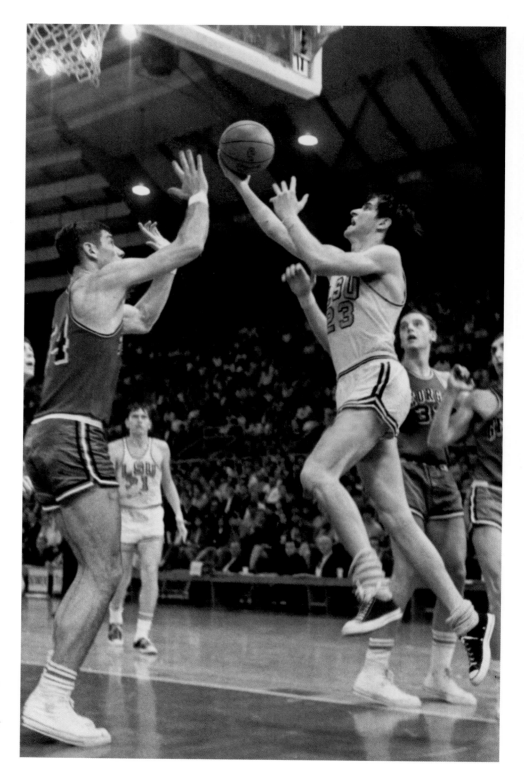

Pete lays this one in over Bob Lienhard (54) for two of his 47 points. Despite being out-rebounded 49–43, LSU made 40 of 76 shots for a sizzling 56.3 percent average.

At that moment, I remember saying something like, "Hey Pete, you need to let me shoot a picture of you holding up those socks." I don't recall the exact words of his response, but it amounted to a polite no. So I didn't get the photo. But looking back now, I think it would have made a great photo for history's sake—Pete smiling and holding up a stinky lucky sock in each hand.

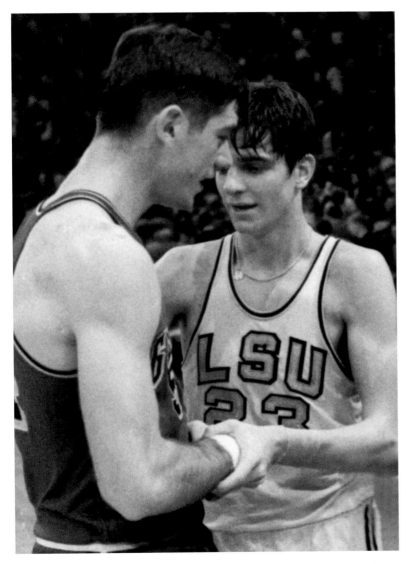

After the game, Pete and Lienhard shake hands and exchange compliments on each other's play. There was no doubt that each knew the other was a worthy adversary.

The Kentucky Game

January 25, 1969

This is another of the games I remember well. Like Alabama in football, Kentucky was one of the teams that I and all LSU fans dreamed of beating. Tiger teams had only beaten Kentucky one time in 35 years, but this year might be different. Unfortunately, LSU's defense was no match for the Wildcats' methodical fast-break offense. Like past years, Kentucky won it by a large margin, 108–96. The win gave Kentucky a perfect 6–0 record in the SEC and knocked LSU down to 2–4 in the SEC and 7–5 overall.

This was the 12th game of the season and was played on January 25, 1969. I have no memory of why I did not shoot photos of the six games between the Georgia game and this Kentucky game. Probable reasons were that some or all of them were away games, and also that the fall/winter semester ended during January and the *Reveille* didn't publish during final exams and the semester break.

The game was played on a Saturday afternoon and shown on regional television. Legendary Adolph Rupp was Kentucky's coach, and I got a few photos of

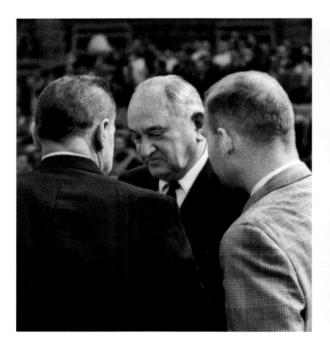 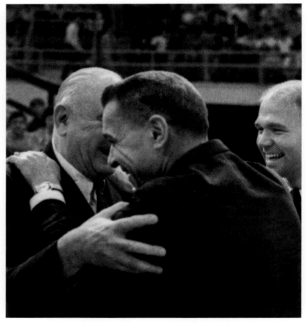

Left photo: Before the game, renowned Kentucky coach Adolph Rupp *(center)* visits with LSU coaches Press Maravich and Greg Bernbrock. Watching them, I had the distinct feeling they were not talking basketball. At one point *(right photo)*, they all broke up laughing at something Rupp said.

him and Press talking before the game. Pete made 52 points and kept LSU in the hunt until near the end of the first half. After that, it was all Kentucky. I remember getting that old feeling of "One of these days, we'll get you guys," just like I felt the year before with Tennessee. I have no other particular memories of this game.

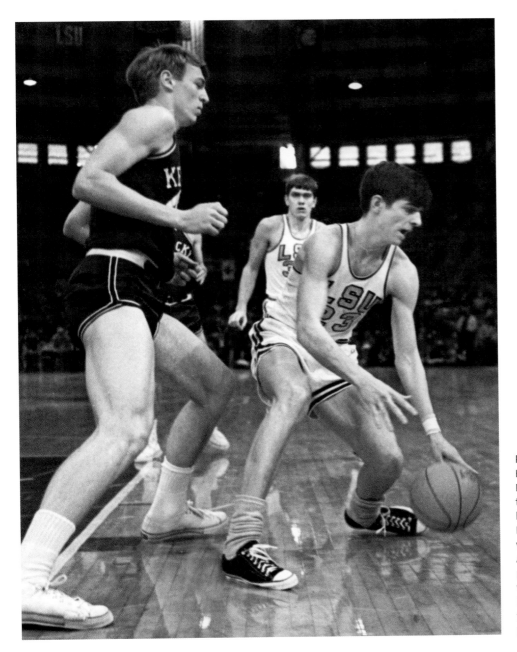

Pete goes up against Kentucky's tall center, Dan Issel, and has to turn back. Again notice how low to the floor Pete dribbles the ball when in close quarters. Although Pete had 52 points for the game, he was cold from the field, hitting only 20 of 48 field goal attempts (41.7 percent).

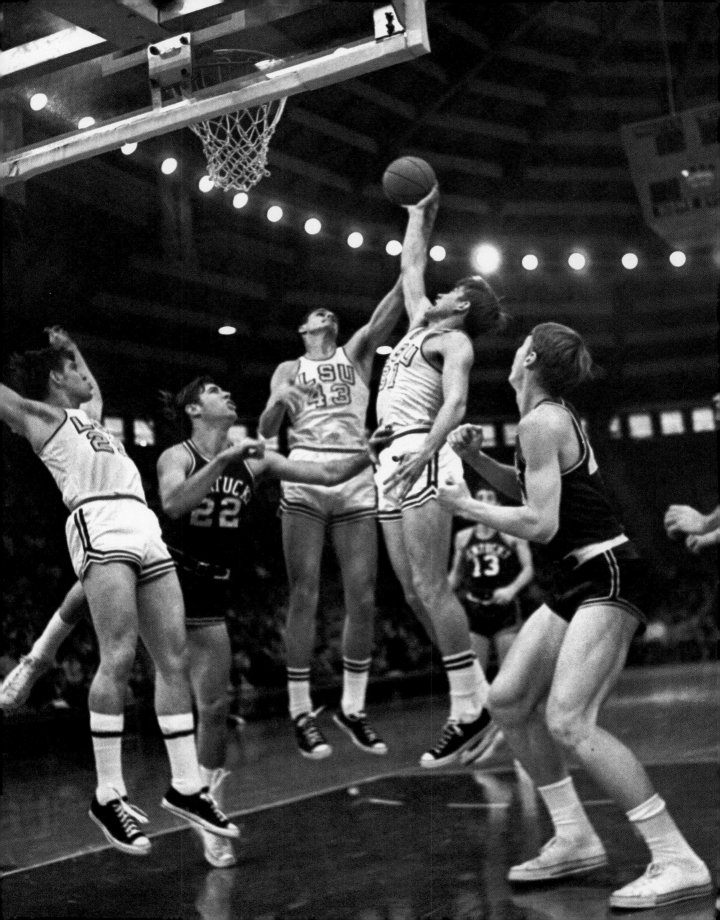

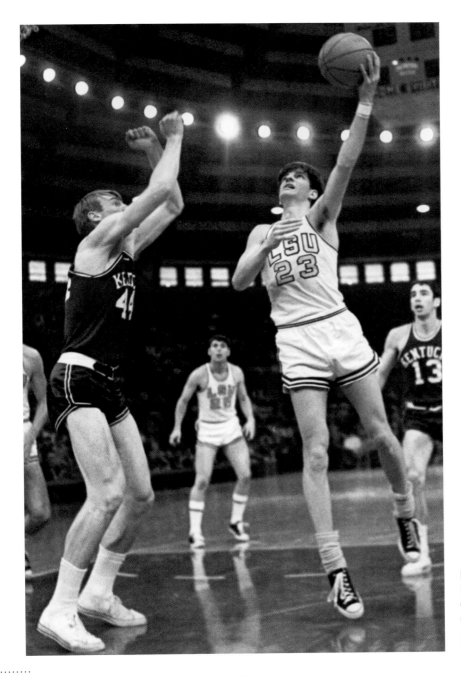

Pete makes one of his left-handed hook shots over Issel (44). Pete could shoot that short hook shot with either hand.

Dave Ramsden (43) and Ralph Jukkola (31) fight for one of LSU's offensive board rebounds. What's curious about this photo is Rich Hickman's (24) backwards swan-dive position. He had just missed a layup and appears to be trying to persuade the referee that he was fouled. Kentucky outrebounded LSU 62–46 in this 108–96 loss.

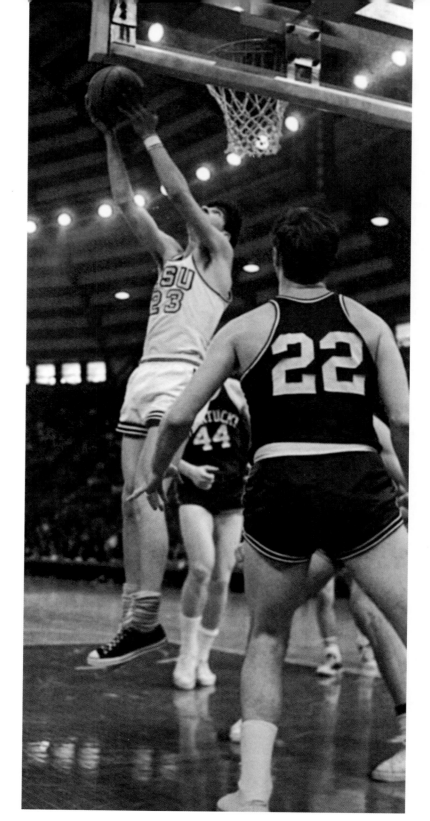

I remember taking this photograph because it was one of the rare occasions when Pete made a two-handed reverse layup. He had rebounded his own missed shot and made the fancy follow-up shot between Kentucky's Mike Pratt (22) and Issel (44).

The Tennessee Game

January 27, 1969

The 13th game of the season was against Tennessee and was played on January 27, 1969. Things were starting to go downhill fast for LSU as the Tigers lost this one 81–68. Pete and the Tigers hadn't won an SEC game since the first two of the season in December against Florida and Georgia.

Newspaper accounts say this game was a defensive gem for Tennessee. In a repeat of last season's home game, the Volunteers held Pete to only 21 points. At the same time, they were hot offensively. At the beginning of the second half, the Volunteers failed to miss a shot from the floor for three minutes and 55 seconds. Despite this, LSU managed to pull within two points on three occasions, but could never get any closer.

I remember this game well because Tennessee began to stall the ball with about two minutes left in the game and in the lead. LSU had to foul, and Tennessee made nine straight free throws to ice the game. During those final minutes, the fans became angry at the officials and began pelting the floor with debris and cups of ice. A technical foul was called on the crowd, which just made the situation worse. When the game ended, deputies had to quickly escort the referees from the floor.

One of the reasons I recall this event is that a cup of ice hit me on the shoulder. A similar incident had occurred a few months earlier during football season. As I kneeled on the sidelines shooting pictures in the final

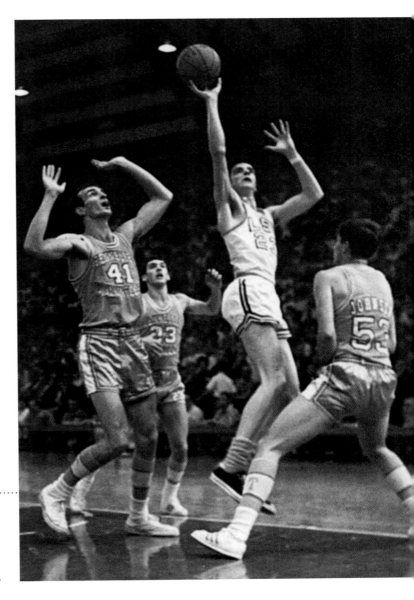

Pete had a hard time scoring in the Tennessee game because of the Volunteers' double- and triple-teaming. Although surrounded by three players of the opposing team, Pete made this shot. However, he managed only 21 points in the game. On the other hand, Tennessee made 28 of 48 shots for a brilliant 58.3 percent average.

minutes of a game, a glass beer bottle sailed past my head very close to my ear and struck the ground right in front of me. It had come from somewhere high in the stands, and I truly believe it would have killed or seriously injured me if it had hit my head. When that cup of ice struck me on the shoulder, I remember thinking, "Well, at least it's not a glass beer bottle."

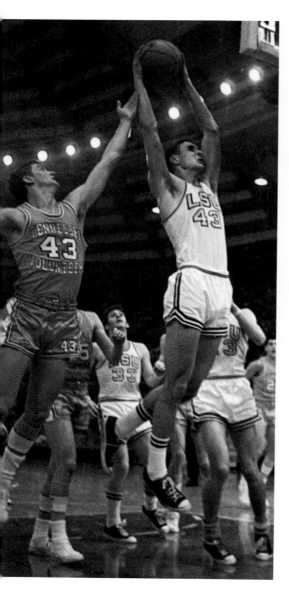

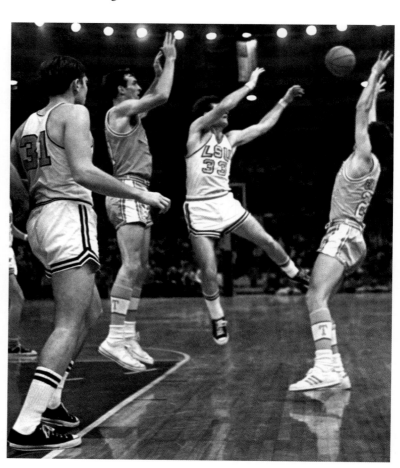

Guard Jeff Tribbett (33), who scored 18 points for LSU, had as much trouble as Pete in penetrating the tough Tennessee defense. Here he passes the ball off to a teammate after his drive to the basket is blocked by Tennessee's Jimmy England. This was one of those very rare occasions when an opposing team player (England) would outscore Pete in a game. England had 29 points to Pete's 21.

With Pete guarded so closely by Tennessee, teammates took up the slack. Here LSU center Dave Ramsden (43) goes up for two of his 12 points.

The frustration of not being able to penetrate or get off clean shots shows on Pete's face. At one point during the Tennessee game, Pete went eight minutes without scoring a point.

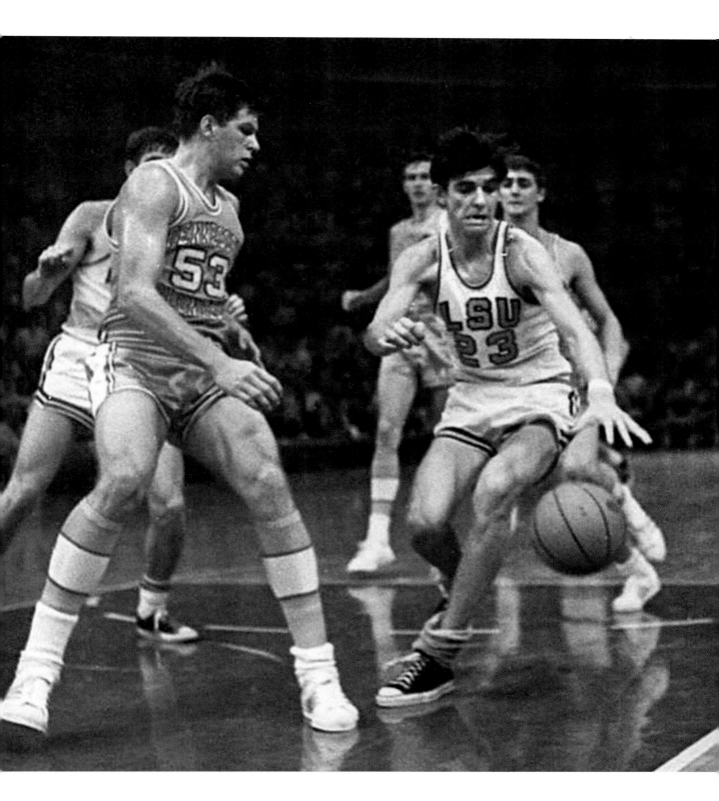

The Pittsburgh Game

January 31, 1969

Now, the Pittsburgh game was one for the scrapbook—not because it was an LSU win by a score of 120–79, but because I took one of my most memorable photographs of Pete. The game was played on January 31, 1969, and was the 14th game of the season.

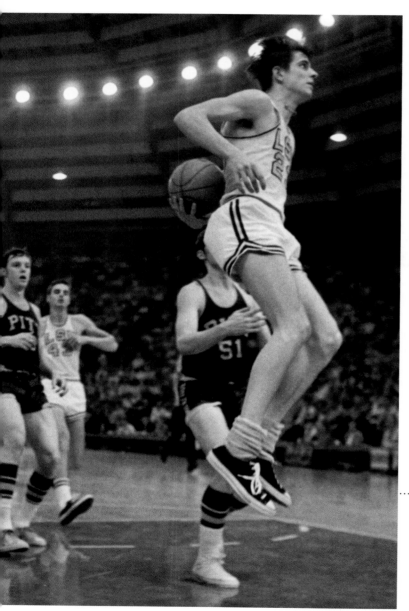

Pittsburgh was not a very good team. It had lost 10 straight games before upsetting West Virginia the week of this game. Pete and the boys were running wild—stealing the ball, fast-breaking, passing the ball off at the last minute. It was a great game from LSU's standpoint. Pete had "only" 40 points and was cold from the field, hitting 13 of 34. However, the Tigers broke their single-game assist record with 27. Of those, Pete had 11.

That brings us to the photograph. It's a great photograph in itself, but when you know the story behind it, it becomes a remarkable statement about Pete's unbelievable talent. The second half was less than two minutes old, and LSU was leading 70–36. All through the first half, Pete was having a field day stealing the ball, rushing down the court on a fast-break, and passing off at the last second to Jeff Tribbett, Ralph Jukkola, or Rich Hickman for easy layups. To picture this correctly, you have to know that all of these last-second assists were passes between the legs, behind his back, or to one side while looking the other way.

This photograph from the Pittsburgh game captures one of Pete's all-time best moves. After a fast-break, Pete stops suddenly about 10 feet from the LSU basket, leaps into the air, brings the ball completely around his back to his other hand, shoots the ball, and makes it. I don't think anybody who was there will ever forget that move. Certainly the Pittsburgh guy trailing the play at left has a look of disbelief on his face.

Well, this time Pete either stole the ball or got a rebound (I don't remember which), but ended up fast-breaking down the court with the Pittsburgh players in pursuit. I don't know which LSU player was off to his side (he is not in the picture), but everyone was waiting for that last-second pass to him for an easy two points. That's when Pete suddenly stopped about 10 feet from the goal, leaped into the air, brought the ball completely around his back to his other hand, and made the shot—nothing but net! It was incredible to see. I shot the photo just as he was holding the ball in the center of his back, while still high in the air.

Believe it or not, I saw the picture in the camera when I took it. Because of the angle I had, I knew I was the only one that got that shot. I couldn't wait to develop the film. Sure enough, it was just as I saw it in the camera when I snapped the picture. I was so proud of that photograph that I made extra copies and gave one to the LSU Sports Information Office and one to Press and Pete. Press had that photo in his office for at least the rest of the season. Sports Information used the photo on the cover of the program for the Auburn game about two weeks later. I still have a copy of that program signed by Pete and the whole team. When I took it into the dressing room and had the team sign it after the Auburn game, I kidded Pete, asking, "Could you turn a little more next time? That way, I'll have something better than your profile." By the way, that photo is the one I see most often reproduced in books and other publications and attributed only to "LSU Sports Information."

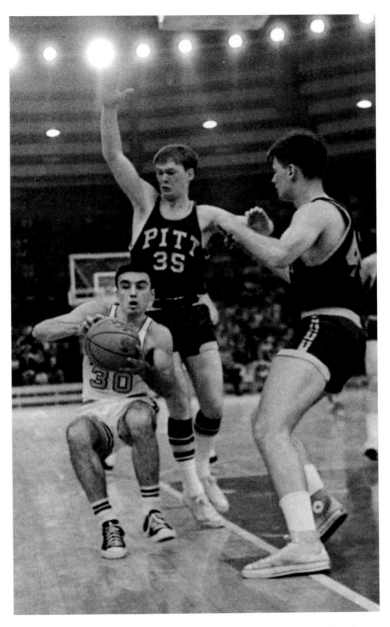

Because this game was such a lopsided victory, Press cleared the bench later in the game. Here little 5'8" Rich Lupcho (30) drives into the middle of trouble as the taller Pittsburgh players surround him. Rich failed to score any field goals, but was three of six from the free-throw line.

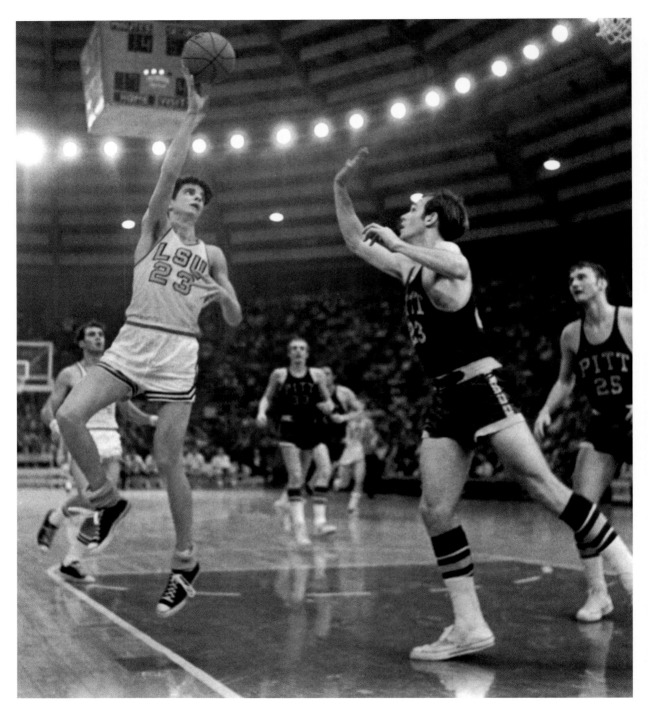

Here again is that rolling hook shot of Pete's. But unlike the hook shot shown earlier from the Kentucky game, this one is from the right side of the court with Pete's right hand. The shot was good. Pete had 40 points in this 120–79 blowout of Pittsburgh.

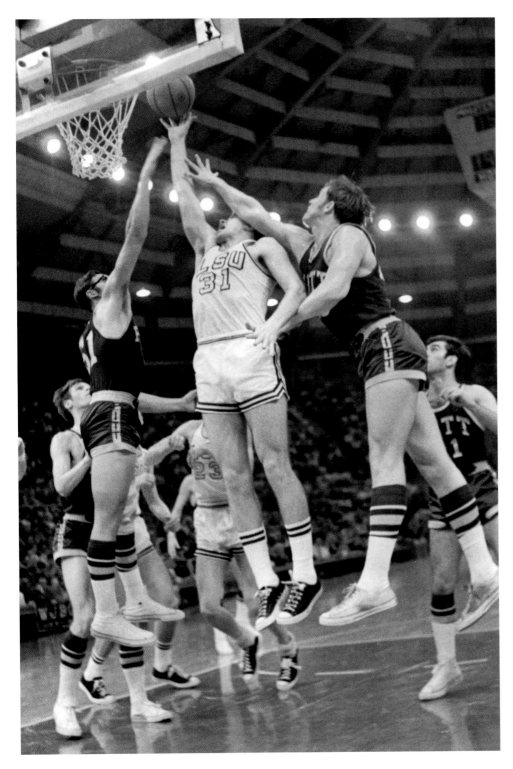

Ralph Jukkola (31) manages to tip in an offensive rebound while getting fouled by a Pittsburgh player. Notice not only the right arm across Yuk's face, but the gentle shove from the Pittsburgh player's left hand.

The Next Five Games

To be honest, I don't remember much about the next five games I photographed. The Ole Miss, Mississippi State, and Alabama games were the 15th, 16th, and 17th games of the season and were played on February 1, February 3, and February 8, 1969. The final two games I photographed, Auburn and Vanderbilt, were the 20th and 21st games of the season and were played on February 15 and February 17.

I know I was there for all of these games, but my thoughts were anywhere except on the action. In the shadows of my mind, I can still remember my mother being hospitalized for the final time during this period, and having the certain knowledge that she would die soon from cancer. I was only going through the motions of attending the games in order to fulfill my obligations to the *Reveille* and my classes.

Being quite down emotionally, I shot only 12 photographs of the Ole Miss game and none are really special, although a few are included here. I shot only 24 negatives at the Mississippi State game, but some of those are quite good. And finally, my *total* number of negatives for the Alabama, Auburn, and Vanderbilt games is 33. That might seem really low, but let me quickly add that I have some good shots. Because I began my photography career with no money for extra rolls of film, I had learned to make every shot count. I will give you some brief synopses taken from the *Reveille* and newspaper reports since I recall so little from these games.

The Ole Miss Game

February 1, 1969

The night after the Pittsburgh game, LSU played Ole Miss. The Rebels beat LSU 84–81 in overtime to add another SEC loss to the record. The sixth straight loss in conference play left LSU at 2–6 in the SEC and 8–7 on the season.

The story I wrote for the *Reveille* says that Pete was held to 31 points while Ole Miss's Ken Turner scored 36 points. That was one for the record books. Nobody ever outscored Pete, especially before 9,200 fans packed into Parker Coliseum. The statistics were fairly even, which accounts for the close score and the fact that the game went into overtime.

Other newspaper accounts say Pete was cold from the field, hitting only 11 of 33 shots, but he did hit 9 of 13 from the foul line. LSU had its chance to win at the end, but could get no closer than one point. Leading 82–81 during the final minute of overtime, Ole Miss missed a foul shot, which was rebounded by LSU's Dave Ramsden. He immediately called time-out with 33 seconds left. Pete then

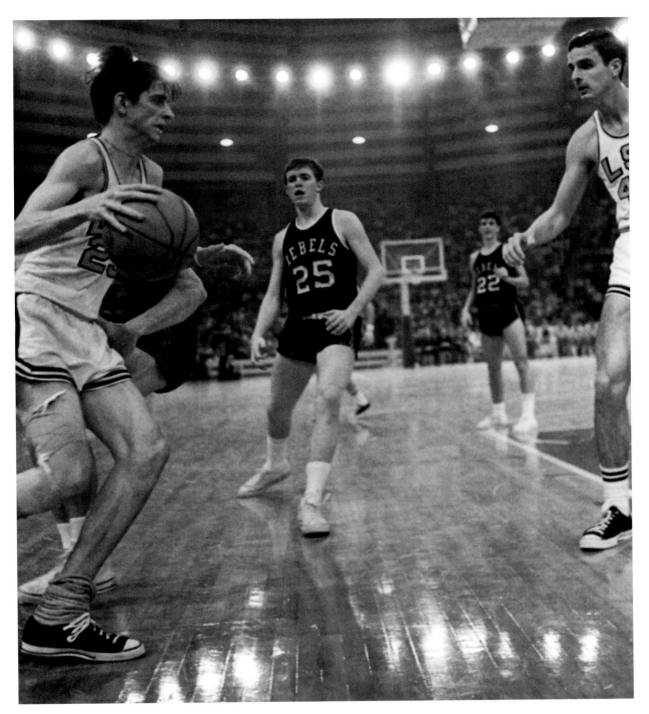

This shot from the Ole Miss game captures Pete on one of his familiar baseline drives. Notice that his right leg is wrapped because of a recent injury. Pete was off his game and was outscored by Ole Miss's Ken Turner 36 to 31 in an 84–81 overtime loss.

missed a shot from the corner and Ole Miss rebounded and was fouled with 10 seconds left. The Rebels missed the free throw but rebounded the ball. Pete was forced to foul, resulting in two made free throws by the Rebels to wrap up the game.

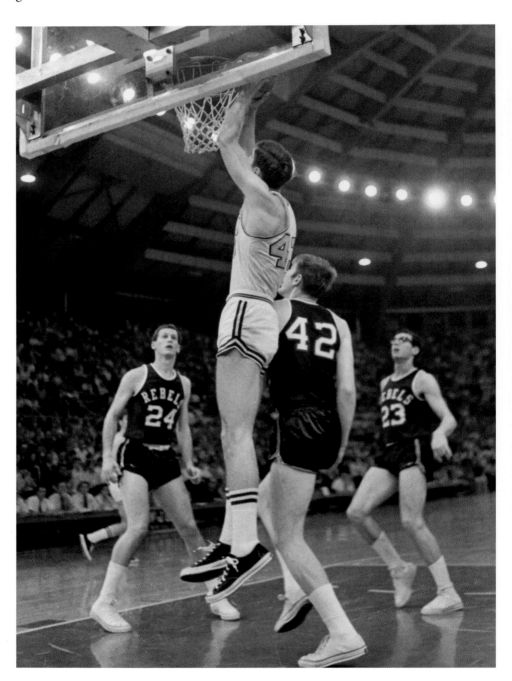

LSU center Dave Ramsden (43) goes up over Ole Miss's Tom Butler (42) to score two of his 15 points. Dave put in one of his best performances with 19 rebounds, despite sitting out most of the second half with foul trouble.

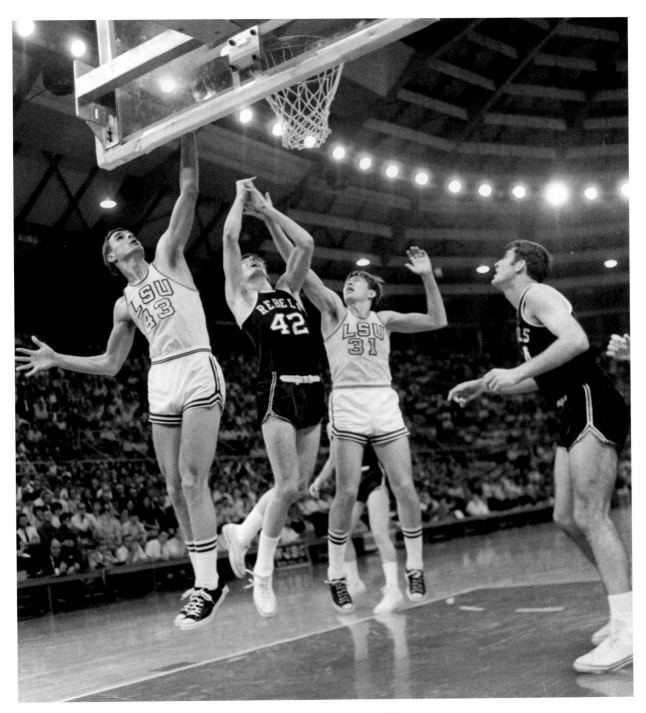

Here is a good shot of LSU's top two rebounders, Ramsden (43) and Jukkola (31), going up against Ole Miss's Tom Butler (42). Yuk had been the team's top rebounder in the 1966–67 and 1967–68 seasons, and Dave was the team's top rebounder for this season, 1968–69.

The Mississippi State Game

February 3, 1969

Two days after the Ole Miss game, LSU came out of its SEC six-game losing streak in a big way by beating Mississippi State 95–71. I took some pretty good photographs, even though I didn't expose that many negatives.

Again, I don't remember much of anything about this game, but according to the *Reveille* story I wrote and other newspaper accounts, a crowd of 7,500 watched as Pete scored 33 points. These stories note that the entire team was hotter than a firecracker, with the Tigers making nearly 54 percent of their shots. Ralph Jukkola had 14 points, Jeff Tribbett had 18 points, Dave Ramsden had 13 points, and Danny Hester had 17 points. In his first starting assignment, Hester pulled

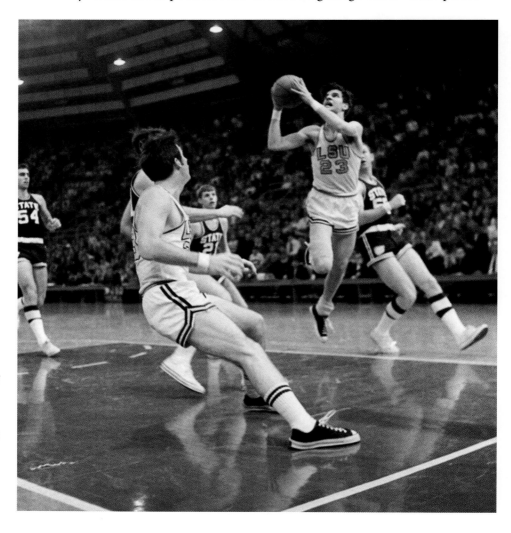

Pete could do more with the ball while he hung in the air than anyone before or since he played. At least in my photographs, it almost seemed like some kind of weird ballet. In this photo, he takes the shot with Jeff Tribbett in the foreground ready for any possible rebound. The play occurred on a fast-break.

down 20 rebounds and played outstanding defense. It truly was a team effort. It is important to note that the above five players did all the scoring for LSU and played all but the last 1:07 of the game. The win gave LSU a 3–6 record in the SEC and a 9–7 record for the season.

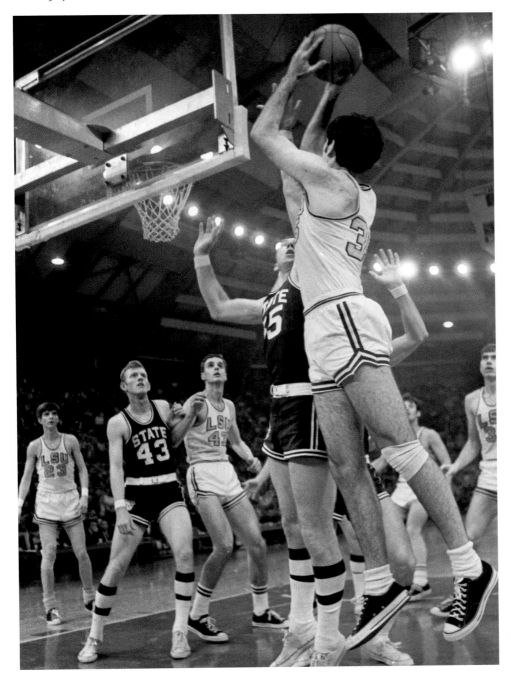

LSU's Danny Hester (35) goes up for a difficult shot over Mississippi State's John Guyton (55), while State's Manuel Washington (43) fights for position with Dave Ramsden (43) under the basket. In his first start, Danny scored 17 points, pulled down 20 rebounds, and played exceptional defense that limited his Mississippi State man to one field goal in 10 attempts.

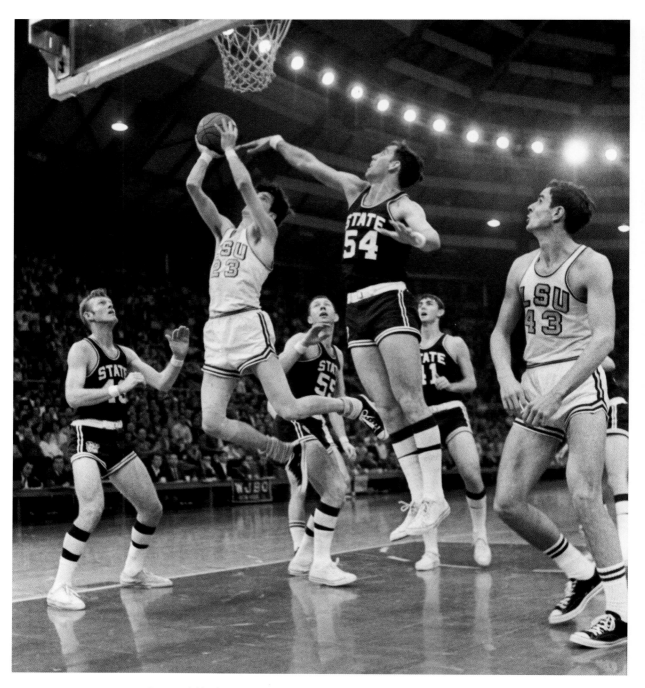

Pete could look awkward on some shots as he fought for position. He made this shot as part of the 33 points he scored in the 95–71 blowout of Mississippi State. It was LSU's first SEC victory since the first two SEC games of the season.

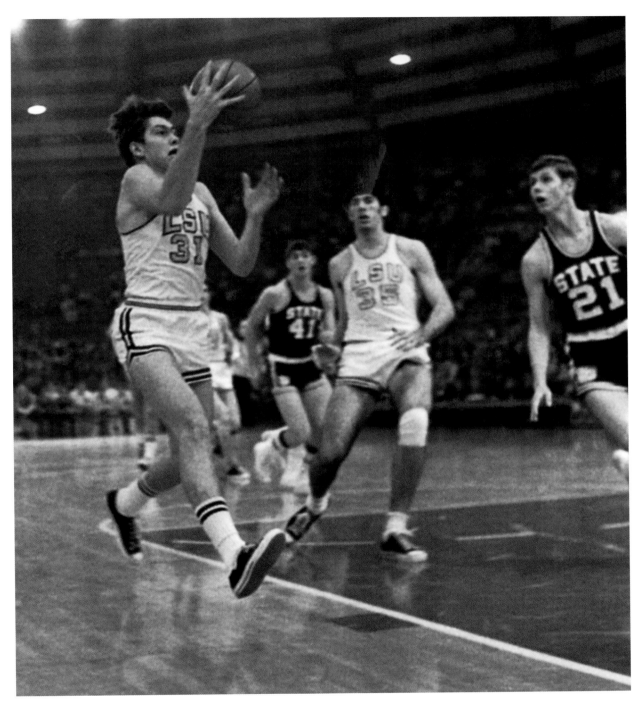

Ralph Jukkola (31) is about to put in an easy layup as Mississippi State's Donnie Black (21) rushes in to attempt a block. Danny Hester (35) looks on. All five of LSU's players scored in the double digits.

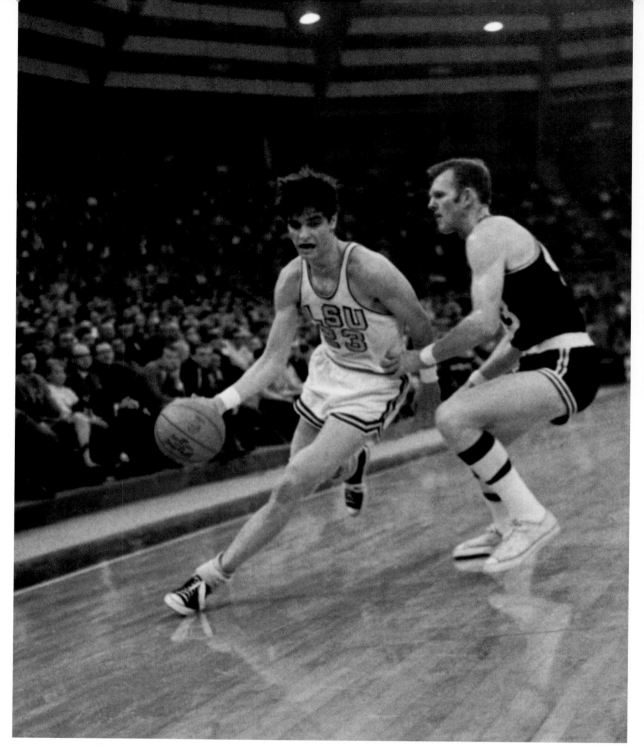

I shot dozens of photographs of Pete that are almost identical to this one. The reason this one is so appealing to me is the position of Pete's left foot. It is practically on edge. And notice the right foot is in the air. Even when dribbling, Pete had such incredible balance that minimal contact with the floor was needed.

This is one of the few photographs I have of one of Pete's extraordinary passes where the ball is still visible in the photograph. He was so sudden with his passes between his legs, behind his back, or to one side or the other that the ball was gone and the play over before we photographers could take the picture. This pass was between his legs on a fast-break to Rich Hickman (out of photograph). Rich put the ball in for two of his four points.

The Alabama Game

February 8, 1969

The next game was against Alabama and was an 81–75 win for LSU, moving the Tigers' record to 4–6 in the SEC and 10–7 overall. The crowd was back up to capacity to see Pete score 38 points. Dave Ramsden and Danny Hester were the only other Tigers in double-digit scoring, with 16 and 11 respectively.

One thing I vaguely remember about this game was that Pete was limping badly. Newspaper reports say he had a strained knee, a wrenched back, and a bad heel. I did see him hurt his knee in an earlier game—Pittsburgh, I think—and my photos show his right knee and leg wrapped beginning with the Ole Miss game. But at that time, as I recall, he had only a slight limp. I asked about it one day when we were in Press's office. My memory is that Pete told me it was nothing serious and he would be okay for the game. I don't remember which game he was referring to, but I am almost sure it was one prior to the Alabama matchup. For this reason, I believe his leg must have gotten worse or was reinjured before the Alabama game. However, none of my stories in the *Reveille* mention the limp or an injury.

I had forgotten about the following incident at the Alabama game until I was reminded of it while reading the newspaper account. On one play, Pete went for the ball and ended up kicking it out-of-bounds toward the scorer's table. Besides the press, radio, and game officials at the table, there sat Bud Johnson, director of Sports Information. The ball hit him hard, squarely in the eye. It stung him pretty good, but really didn't injure him except for leaving a small discoloration beside his eye. Later in the week, I took the opportunity to joke with him about it in his office. I remember saying something like, "What did you do to get Pete so mad at you?" I don't recall Bud's reaction, but since he has a good sense of humor, I'm sure he laughed.

The ball-in-the-eye incident was good for joking with the other party, too. A few days later, I saw Pete walking across campus and commented, "Pete, you've got to take it easy on Bud Johnson. After all, he works so hard to make you a star." Pete gave me this puzzled look that told me he didn't know what I was talking about. I then explained what had happened. He laughed and swore he didn't know the ball had hit Bud.

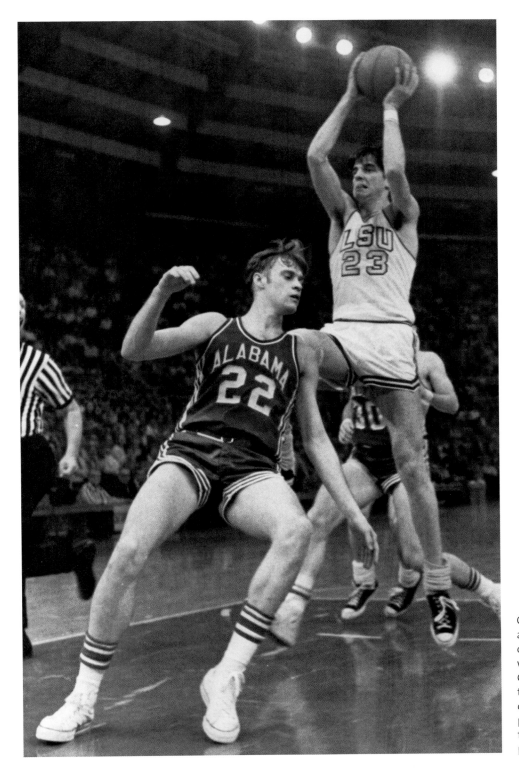

One thing you could say about Pete's offensive drive—don't get in the way! Here, Alabama's Gary Elliot (22) finds out the hard way. Elliot was called for a foul on the play, and Pete sank the free throw for a three-point play.

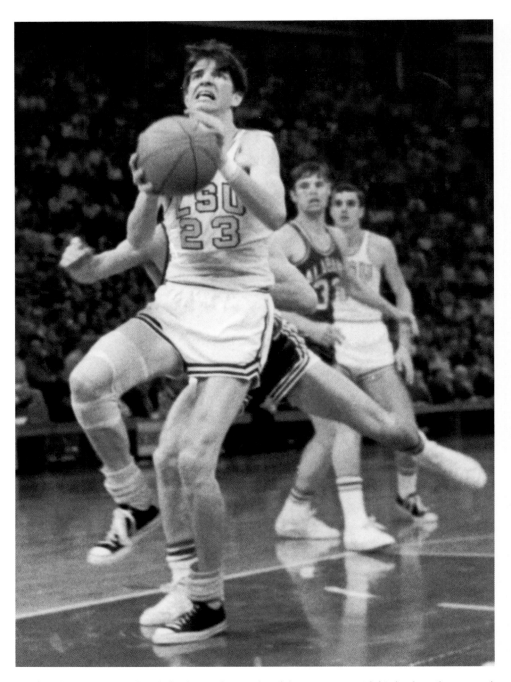

Pete's right knee was definitely bothering him in the Alabama game. With his leg heavily wrapped above and below the knee, Pete took several spills. Each time, however, he rose slowly to his feet and continued to play. Even with his injury, Pete scored 38 points on 15 field goals (out of 30) and hit eight of 12 at the free-throw line.

The Auburn Game

February 15, 1969

Three games after Alabama, LSU played Auburn at home. The Tigers won 93–81, giving them a 5–7 record in the SEC and an 11–9 record for the season. With six games left, the season could still be a winning one or a losing one.

Some 8,000 fans watched as Pete scored 54 points and broke two scoring records in one game. When he hit his 1,972nd career point, he became the top scorer in LSU basketball history, breaking the record of 1,970 points held by Bob Pettit. The second record was scoring his 2,000th point and topping the old National Collegiate Athletic Association (NCAA) two-year scoring record held by Cincinnati's Oscar Robertson for the years 1957–58 and 1958–59.

I don't know if I actually have these two records on film because none of my negatives of the game carry those notations. It could be that I do have them, but was remiss in marking them as such. After all these years, I just don't know.

Late in the first half, Pete injured his ankle again and went down around midcourt. Press and the other coaches rushed out and spent several minutes checking him as the crowd watched anxiously. Finally Pete got up, slightly limping, and continued to play. I have photos of the event, taken from under the LSU goal with a wide-angle lens. I was a long way from the scene, so the resulting quality is not great.

With Pete's right knee wrapped and continuing to bother him, he went down near midcourt in the first half of the Auburn game, injuring his ankle. Press and assistant coaches Jay McCreary and Greg Bernbrock attended to the ankle, and Pete remained in the game. He scored 54 points in the 93–81 victory.

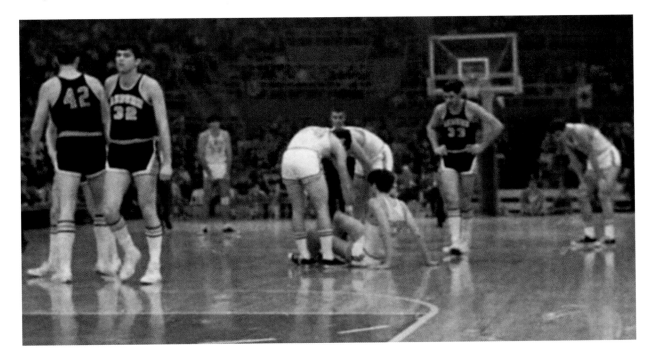

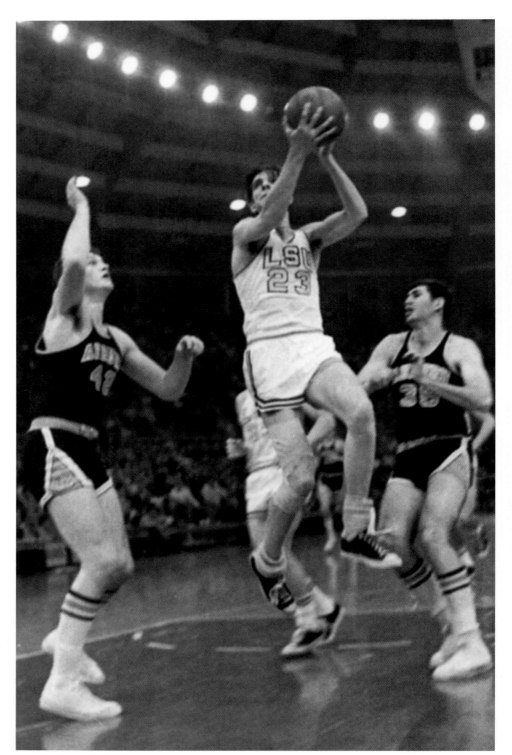

After Auburn closed
LSU's nine-point half-
time lead to 43–39 early
in the second half, Pete
hit this awkward driving
layup to stretch the lead
back to 51–41. Pete was
favoring his injured right
ankle heavily during
the second half, but his
outstanding shooting
helped the Tigers main-
tain their 12-point win-
ning margin throughout
most of the second half.

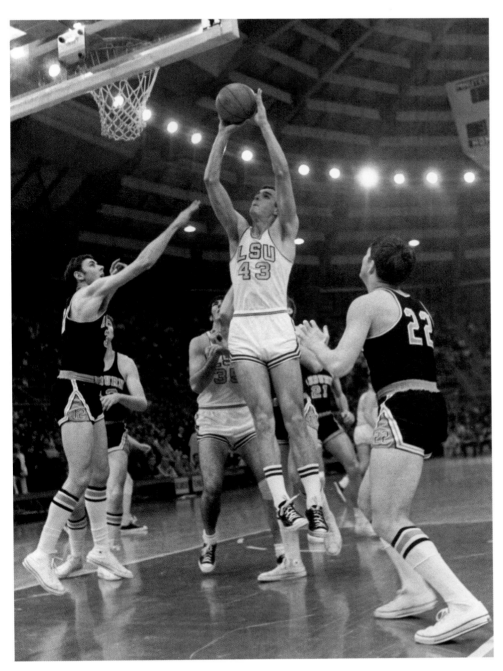

With Pete favoring his right ankle, some of the scoring burden was taken off of him by Dave Ramsden (43). Here, Dave scores one of his six field goals as Auburn's Wallace Tinker (33) and Carl Shetler (22) move in too late to block the shot. Dave also led all LSU rebounders with 11.

The Vanderbilt Game

February 17, 1969

The last basketball game I photographed as a senior at LSU was the Vanderbilt game on Monday, February 17, 1969. A crowd of 9,300 people attended this last home game of the season. All five of the remaining games were to be on the road—remember, Parker Coliseum's dirt floor beneath the portable basketball court was needed for the annual livestock show, which always began about this time in February. I don't recall feeling anything special about this being the last basketball game of my college career, but then my mother was in the hospital dying. She would pass away one week later to the day.

Pete had 35 points in the game, but Vanderbilt won 85–83. I do remember one particular incident in this game—not for a photo I took, but for a photo I missed. Had I gotten that photo, I know it would have been a classic, reproduced many times over the years in books, TV specials, and publications about Pete. I am certain of this because I would have published it in the *Reveille* alongside my game story, and also given prints to Sports Information and to Pete and Press.

This is what happened. Pete was expelled from the game with 1:52 left after he tried to drive to the basket from the right side and lost the ball out-of-bounds. At the time, the Commodores were leading 84–81. It was still anybody's game, and the competition was fierce because it was the final home game for LSU's five seniors—Ralph Jukkola, Rich Lupcho, Dave Ramsden, Chuck Legler, and Rusty Bergman.

As practically everyone knows, Pete was one of the most competitive players ever to take the court. He was very aggressive when it came to shooting from anywhere on the court, but especially when driving the baseline to the goal. Over the years, I had seen him do it in heavy traffic hundreds of times. The defenders would always crowd him, double-team him, and generally make it tough to get to the goal.

That night, with the game on the line, Pete drove the baseline and was heavily crowded by a Vanderbilt defender. Somehow, Pete lost control of the ball and went down on the floor. The ball went out-of-bounds right beside me. The referee called it Vanderbilt's ball.

Although taken about halfway through the first half of the Vanderbilt game, this photograph highly resembles the play on which Pete was expelled from the game with 1:52 remaining. He had tried to drive to the basket from the right side and was closely guarded. Pete lost the ball out-of-bounds and contested the call by squaring off with the official, who promptly called a technical foul and expelled Pete.

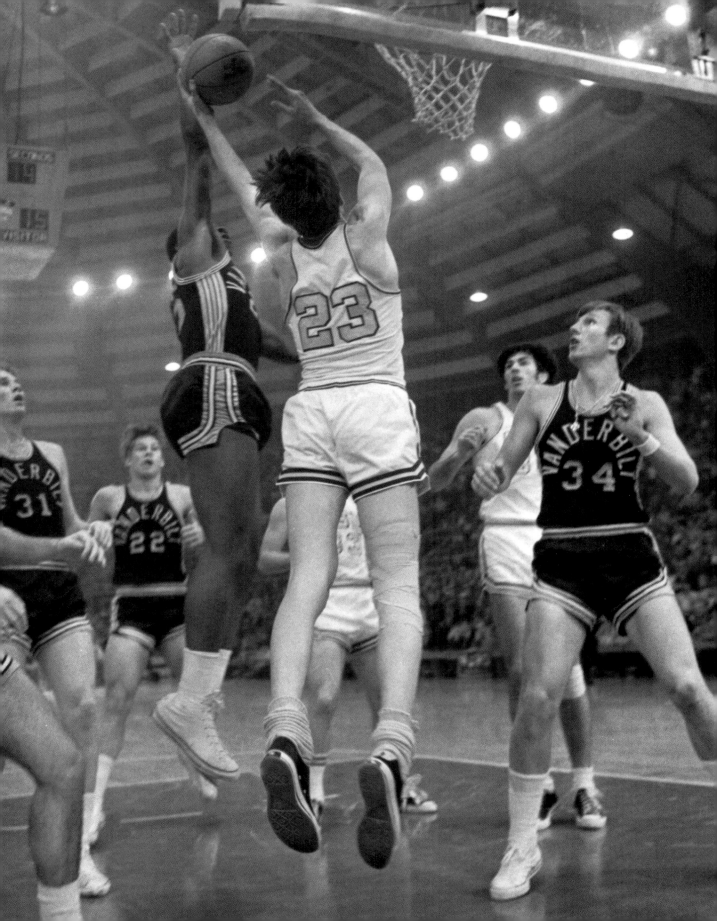

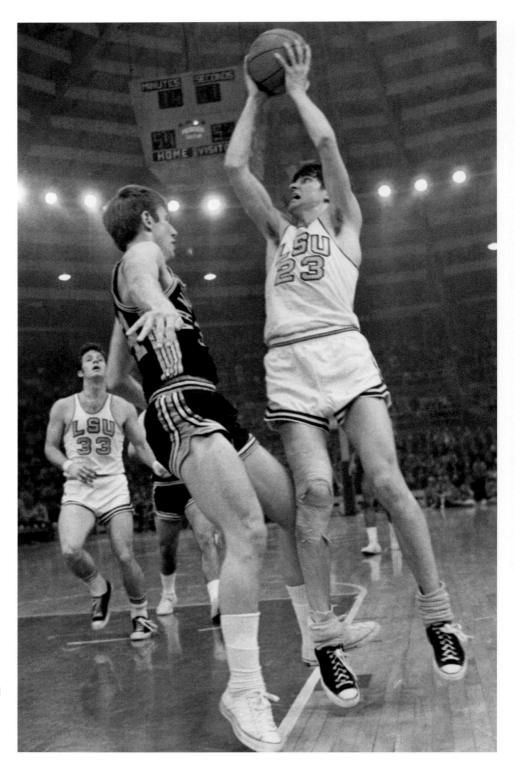

Before being expelled, Pete managed to score 35 points. Nevertheless, Vanderbilt won the game by a score of 85–83. The setback left LSU with an 11–10 overall record, and 5–8 in the SEC. This was the last home game of the season.

Now, Pete couldn't have been more than eight feet or so away when he went down, perfectly within the zone of my camera's focus. When the ball shot past me, I looked up from the camera instead of watching the scene through the lens like a "good" photographer should. Pete lost his temper and immediately jumped to his feet.

With an angry expression, he drew back his fist at the referee for not calling a foul on the Vanderbilt player. The instant I saw that, I saw a memorable photo. Unfortunately, the camera was near my lap, and by the time I got it up to shoot the picture, the photo was gone. The referee immediately called a technical foul and expelled Pete. After all these years, I can still clearly see that picture in my mind. Missing that photo is one of the big disappointments of my college journalism career.

Pete's expulsion probably cost the Tigers the game because Vanderbilt made only one of six free throws in the time remaining. While LSU's Danny Hester did score one two-pointer, the Tigers might have won with Pete in the game because they missed the final shot of the game. The loss left LSU with a 5–8 SEC record and 11–10 overall.

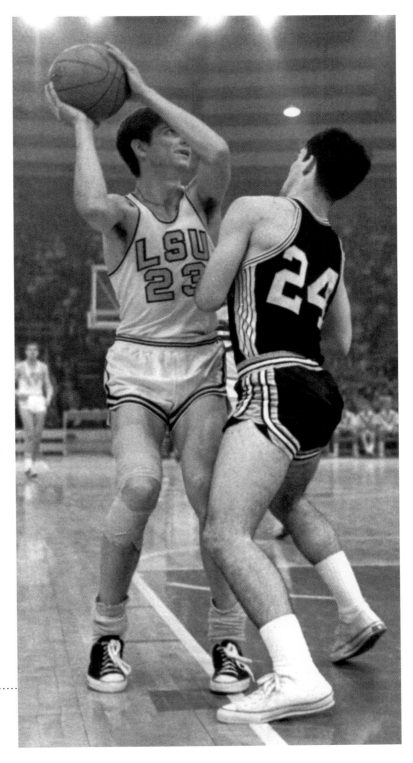

One of the last photographs I took before Pete left the game was a typical one of him being seriously crowded by an opposing team player.

The Remainder of the 1968–69 Season

LSU went 2–3 for the rest of the season and finished 7–11 in the SEC and 13–13 for the season. Like I said, all five of these games were on the road. It was hard enough to win in the SEC, let alone finish on the road at Kentucky, Tennessee, Ole Miss, Mississippi State, and Georgia. LSU lost against the first three and won the final two.

One rather odd incident happened near the end of the season. I don't recall if it was before or after the Vanderbilt game. I remember being alone with Pete and Press in Press's office, just "shooting the bull," and somehow the subject of friends came up. It led to a comment by Pete that I remember exactly as he said it: "Yeah, next year I will have more friends than I need when I sign that big contract."

I clearly recall thinking what an odd comment it was. To this day, I really don't know exactly why Pete said it or what he meant by it because it was outside the context of our discussion. Perhaps he was commenting on all the "friends" that hung around because he was a basketball star. If so, it may mean he knew it would probably get worse once he became a rich professional basketball player. But I honestly am not sure what he meant by it.

As I said earlier, my observation had always been that Pete really wasn't bosom buddies with anyone (including me) outside of his teammates, coaches, and perhaps the team managers. In any case, I think the remark is a good indication of the isolation he probably felt at the time. Knowing what I know now, I think it also reflects on the personal difficulties he was experiencing at home with his mother.

The last basketball event of my senior year was covering and photographing the basketball awards banquet on March 10, 1969. I have tons of photos of that banquet, but they can all be summed up in a few words. Pete was awarded the Most Valuable Player Award (was there ever any doubt?), the Free-Throw Accuracy Award, and the Borden Award for Most Assists. He shared the Harry Rabenhorst Award for Leadership with Jeff Tribbett. Dave Ramsden received the Most Improved Player Award, the Most Rebounds Award, and the Field Goal Accuracy Award. Rich Lupcho got the Scholastic Award, and my friend Ralph Jukkola received the Team Captain's Award.

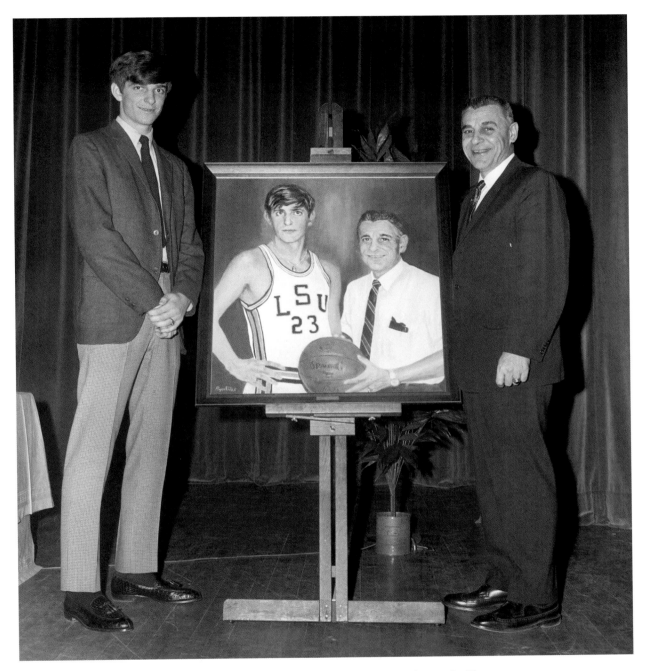

Pete and Press pose with their portrait at the basketball awards banquet on March 10, 1969. The portrait was painted by artist Alyce Ellis.

The House That Pete Built

There is one other thing worth mentioning that happened before the end of my senior year. Ever since Pete had started filling the "Cow Palace" for nearly every game, a groundswell began for the building of an LSU Assembly Center to replace the antiquated Ag Center. Plans proceeded quickly for the $11.5 million facility. Supposedly, it was not to be primarily an athletic center, but everyone knew the main reason for its construction was Pete Maravich. The crowds his games attracted had highlighted the need for a new facility more than anything else could have.

As I said earlier, one of my beats for the *Reveille* was Campus Security. One day in the spring of 1969 (I believe it was after the completion of the basketball season), I was visiting the office of Campus Security chief Charles R. Anderson on a story. I had become good friends with the chief, and we were just sitting around talking after I got some information for a story to be published in the *Reveille.* At one point in our conversation, he looked at me and said, "You know, they start construction on the new Assembly Center tomorrow. You need to walk out there and shoot a picture of the stadium from that open field. It will be the last time anyone will ever have that view."

I hadn't thought about it, but he was right. The Campus Security office at that time was just north of the football stadium, on the east side of the open field where they would build the Assembly Center. I and thousands of ROTC cadets over the years had drilled on that field. It did indeed present a great view of the LSU stadium that would be lost forever.

I had my camera with me and immediately headed out into the middle of that huge field to shoot a few pictures looking toward the stadium. It was late in the afternoon, probably around 4 P.M. or so, and all I had was black-and-white film. The sun angle wasn't the greatest, but I did what I could to get a good shot. I tried several different distances from the stadium, each time coming closer to it. Ironically, the photograph I settled on as the best was taken from the approximate location of the Assembly Center's basketball court. Just as Chief Anderson pointed out, it was the last photo taken of that view. Huge dirt movers started digging out the area the next day.

The Assembly Center was completed in 1971, more than a year after Pete's senior year, and was nicknamed "Pete's Palace." Pete never got to play in it.

This is the last photograph taken of LSU's football stadium from the site of the Assembly Center. Taken late on the day before construction began, it shows part of what was then a huge open field just north of the stadium. Ironically, I took this photograph from what turned out to be the approximate location of the Assembly Center's basketball court.

3

The Shot

The Ole Miss Game, 1970

Shortly after graduating in May 1969, I began working as a general assignments reporter for the afternoon newspaper in Baton Rouge, the *State-Times*. I don't remember seeing Pete or Press again during the summer and fall of Pete's senior year, and I know I did not attend any of the basketball games of the 1969–70 season—except one.

Naturally, I kept up with Pete and the team and was well aware of him closing in on the all-time college scoring record of Oscar Robertson. When the Ole Miss game rolled around on January 31, 1970, I, and just about everyone else, figured that Pete would get the 40 points he needed to break the NCAA record. Robertson's career total was 2,973 points. Before the game, Pete's total was 2,934. If he hit his average so far that year of 46.3, the record would be his.

Armed with that knowledge, I put in a call to Bud Johnson at Sports Information. Everyone was trying to get a press pass for the game, but I pleaded with Bud, promising to give Sports Information some of my photos if he would grant me a pass. As always, Bud came through and I got the photographer's pass.

There was such a demand for tickets that Athletic Director Carl Maddox arranged for the game to be broadcast on closed-circuit TV to the LSU Union. In those days, tickets for the public were put on sale at the gate only after all the LSU students who wanted to attend a game were admitted. For this game, that meant *no* tickets would be on sale at the gate.

LSU had not beaten Ole Miss since the 1967–68 season. Ole Miss's record stood at 7–7 on the season and 3–4 in the SEC. LSU was 9–5 on the season and 4–2 in conference play.

Taking my place under the goal that night, I felt like I had never been away. All of the regular photographers were there, as well as a host of new ones I had never seen. It was crowded, but I managed to get the spot I wanted and was loaded for bear with several rolls of film. I was keenly aware that this game would complete my photography record of Pete Maravich.

The game started cold for Pete. After the tip-off, he didn't get a shot off for

85

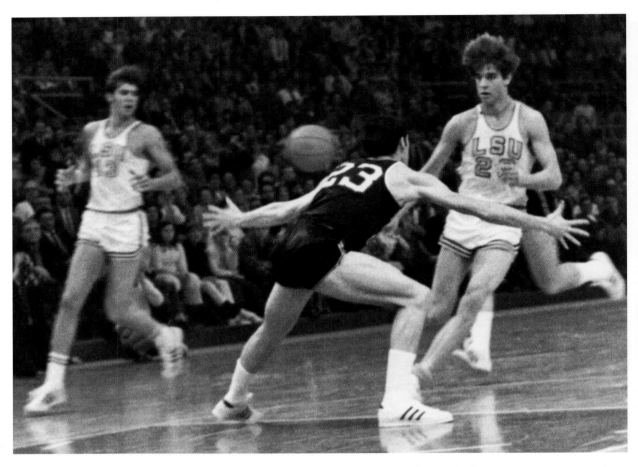

Although Pete needed only 40 points to break Oscar Robertson's all-time NCAA scoring record, he began the Ole Miss game without taking a shot for more than three minutes. He seemed content to hand off the ball to others, who would take the shot. Some of those passes were Pete's signature passes. In this photograph, he has just flipped a "no look" pass to Bill "Fig" Newton (43). Notice that Pete is still looking straight at the Ole Miss defender, who has yet to react to the move.

more than three minutes. He seemed content with feeding the ball to other players, like Al "Little Apple" Sanders and Danny Hester, whose scoring helped build a comfortable lead for the Tigers. Then Pete went on a tear. He scored the Tigers' next 13 points and finished the first half with 25.

The second half started with Pete taking the tip-off and making an easy layup. Now there was no doubt in my mind that Pete would break the record that night. All I could do was hope I was in the right place to get the shot.

We all counted down the points needed until he totaled 39. One more goal, and that would be it. Then, six straight times, Pete came down the court and shot. And six straight times, you could hear the clicks of a hundred camera shutters going off. There were six straight cheers from the crowd of 11,000 as he

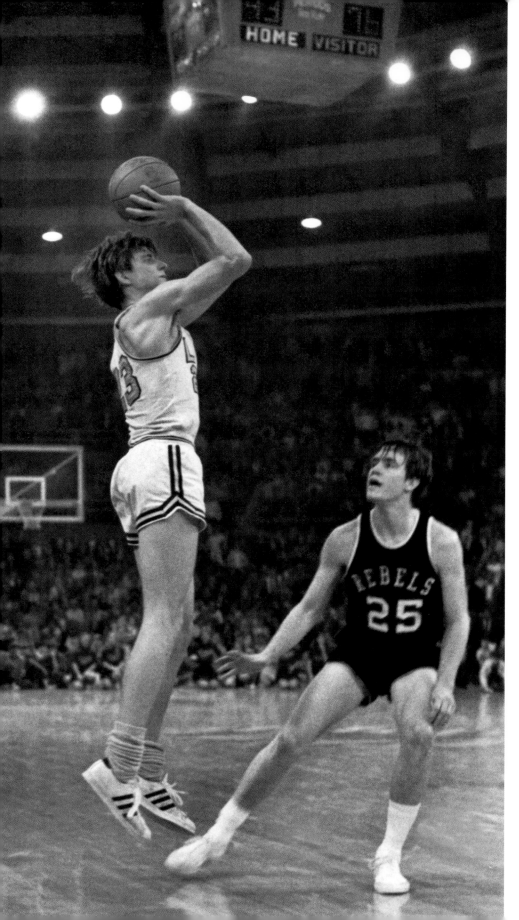

This is the shot heard around the world. With 4:41 left in the game, Pete got an open look at the basket and sank an 18- to 20-footer to break Oscar Robertson's college scoring record. Ole Miss defender Charlie Ward (25) can only watch as Pete sinks the record breaker. I was in a perfect position to get this photograph and couldn't have posed it any better.

released his shots, and six collective gasps from the crowd as the shots bounced off the rim. The tension was terrible.

Then came *the* shot. With only 4:41 left in the game, Pete got the ball about 18–20 feet from the basket and had an open look at it. Ole Miss's Charlie Ward closed in on Pete, but was too late to interfere with the shot. It was wide open—and he made it.

Now when I tell you I couldn't have posed a better shot for me, I mean it. Pete was practically straight out from me, but with enough of an angle so that his raised arm didn't block his face from my lens. I caught him at the top of his jump, with the ball about to leave his hands. All three things in that photo are perfect—Pete at the top of his jumper, Charlie Ward in front too late in trying to defend, and the scoreboard overhead, reading 93–76, the score before he made the goal. Later, after the game, I would jokingly "thank" Pete for breaking the record where I could get a good shot of it.

The entire place exploded in a roar. Pete had started to run back down the court on defense when the referee called an official time-out. His teammates surrounded him, and Al Sanders and Bob Lang hoisted him to their shoulders. A horde of rabid fans and photographers (including me) rushed to the scene at center court.

Pure luck landed me in the right place among the mass of people around Pete. I got several great photos of the jubilation, but there are two that really sum up not only the moment, but Pete's entire LSU career. Both show him looking down from his high perch with the most genuine smile I can ever remember seeing on his face. My favorite of the two also has some of the lights that ring Parker Coliseum's ceiling shining around his head like a crown. That photo has a hand very near Pete's face, reaching up and out of the crowd as if to pat his face in adoration. I think it is my favorite photo of Pete because it shows him at the top of the mountain, while at the same time you can see what I think was the real Pete—an ordinary person like me and you, who worked hard to become the best at what he loved, and succeeding.

When the celebration was over, the game resumed. Only four minutes were left, but Pete scored 10 of the Tigers' last 14 points and finished with 53 for the night. It had been an easy 109–86 victory that pushed LSU's record to 10–5 on the season and 5–2 in the SEC.

There was a press conference held in the dressing room after the game, and like the rest of the press, I fought my way in. I ended up a little behind and to the right side of Pete, but with an angle that afforded me "artistic" shots of Pete

....................

The officials stopped the game, and teammates lifted Pete to their shoulders. Left to right, that's Danny Hester, Al Sanders, Bob Lang, and Jeff Tribbett doing the honors.

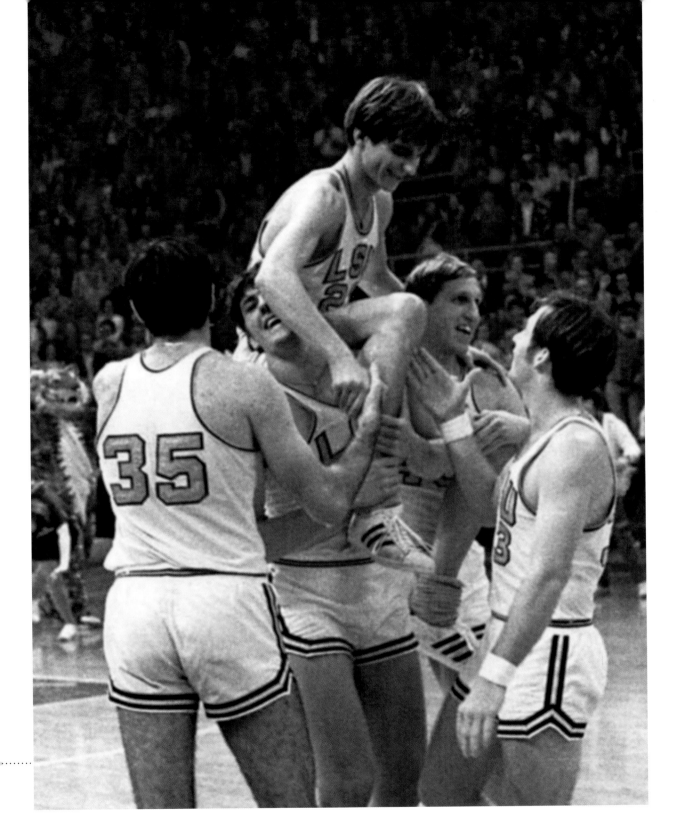

These are two fantastic photographs I shot of Pete during the celebration. He is sitting atop his teammates' shoulders (Al Sanders is at lower left) and has the happiest and most genuine smile I can ever remember seeing on him during his college years. These two photographs show Pete at the top of the mountain.

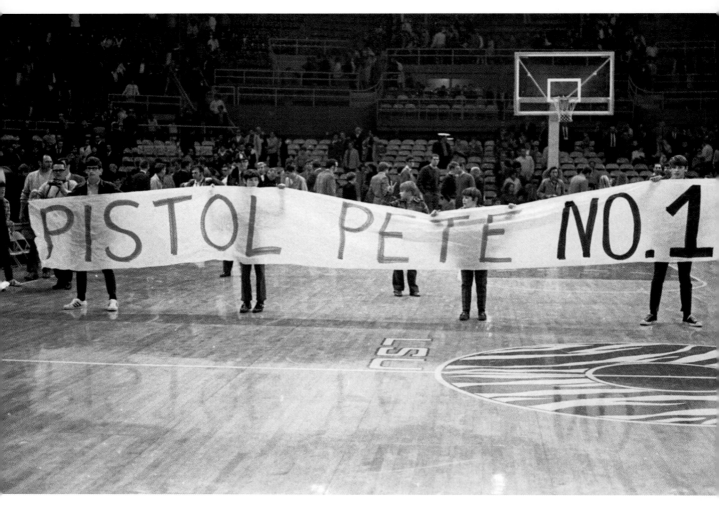

While the fans cheered their approval, some kids came out of the stands and unrolled this huge banner. They paraded it around the court for several minutes before the officials cleared the floor so the game could continue.

looking into the bright lights of the TV cameras. After he and Press answered questions and made statements for everybody, the two posed for some photos. I got several shots of Pete and Press with their arms around each other, but there is only one that I think truly captures the pride and connection between the two. You can see Press with both arms around Pete, pulling him close with this big "proud Papa" smile. Pete has his arm around his dad's shoulder and is smiling. Out of all the photos of that pose that I took, or that I've seen, it is the only one in my opinion that shows the genuine emotions of the moment and the private bond between father and son.

When the press conference was over, everyone started leaving the dressing room and the crowd thinned out. I had a copy of the official score sheet from the game (I still have it) and may be the only person that got both Press and Pete to

A very crowded press conference in the dressing room after the game forced me to take a position to the right and slightly to the rear of Pete. Though I managed some conventional photographs, the luck of the position allowed me to take this somewhat artistic picture. I think it illustrates perfectly that Pete alone was in the spotlight that night.

Although I and other photographers at the press conference took lots of pictures of Pete and Press together, this one is the best I have seen (even if I do say so myself). I believe Press's mission in life was to see Pete succeed in the sport Press so dearly loved. I think Pete lived to fulfill Press's dream to have him be the best ever in basketball. This photograph clearly shows the connection and bond between the father and son.

sign it. A funny thing about that sheet is that Press signed it "Pres Maravich." Why he signed it with only one *s* I will never know. Perhaps he was in a hurry. I watched him sign it, but didn't see the one *s* until a few minutes later. I debated about whether to go back and point it out, but decided it might be a more special item because it had only one *s*. Even today, I don't know if that was a good decision or not.

After leaving the dressing room, I waited on the court near the scorer's table for Pete to come out. That's when I may have taken some of the rarest pictures in existence of the Pete Maravich era. There were just a few people standing around; almost everybody had left when some of the lights were turned off. I still had my camera around my neck and noticed Diana, Pete's little sister, with a group of women. I began a conversation with the women and shot a few photos of Diana because she was sitting there smiling so prettily. Though the arena was a little darker now, I was able to lower the camera settings to compensate and got some good exposures.

The ladies and I were joking and cutting up a little. I told them that I was going to take their picture also. As with most women, they laughingly protested they weren't prepared and didn't want their photos taken. But I kept at it. Then I heard

one of the women say something like, "Take Mrs. Maravich's photo. Don't take mine." I was surprised by the statement. In all the years of taking photos at Pete's games, being around Press's office, and attending sports functions, I had never seen or met Pete's mother.

"Are you Pete's mom?" I asked. "Yeah, that's me," she said. I told her, "You have to let me shoot your picture. After all, I already have some good ones of Diana. I promise you they will be good." At that she said okay, but continued to look away, talking to the other ladies so that her face was in profile. I shot one photo of her in profile. Then I told her something like, "You see, that didn't hurt at all," and she turned while I still had the camera to my eye and made an exaggerated grin my way. I shot another photo before she could turn away.

We stood there talking for a little while about how good or bad the pictures would be. Then Pete and Press and some others came out of the dressing room and I asked Pete to sign the score sheet by his dad's name. To my memory, I shook hands with Pete and Press, told Mrs. Maravich that I was sure the photos would be good ones, and we all went our separate ways.

While waiting for Pete and Press to come out of the dressing room after the press conference, I shot this picture of Diana, Pete's little sister.

One of the women standing near Diana turned out to be Pete's mom, whom I had never met or seen attend any game or LSU function. Although reluctant, she did let me take these two photographs of her. Later, I found out she was practically never seen in public. Therefore, these two pictures turned out to be the rarest photographs I took of the Pete and Press basketball era.

The photos of Diana were great, but I didn't think too much of Mrs. Maravich's. The profile was a good photo, but a side photo doesn't flatter much. The big-grin picture was a little soft on the focus, and I didn't consider it good enough to give to her. Because of that, I never gave Pete or Press any copies. However, I kept some personal prints that I had developed before making my decision not to give them to her. It would be nearly 20 years before I found out about her alcohol problem and the real reason she was never seen at the games or much in public. The two photos I have are real rarities.

The team finished 20–8 in Pete's senior year and was invited to the National Invitation Tournament (NIT) in New York City. This was huge for a team that had come from a 3–23 record just three years ago. In their first game in the NIT, the Tigers played the Georgetown Hoyas and eked out an 83–82 victory. Pete had a tough time with their defense, but won the game on two free throws with nine seconds left. LSU beat Oklahoma in the next game to advance to the semifinals against Al McGuire's top-seeded Marquette team. Marquette beat Pete and the Tigers 101–79. Pete then ended the season on the bench with an ankle injury as Bobby Knight's Army team beat the Tigers 75–68 in the consolation game. LSU's overall record for the season was 22–10.

The last time I saw Pete in his senior year was at the basketball awards banquet on March 23, 1970. Again, I showed up to shoot pictures, mostly because it was Pete's final function at LSU. Like the year before, Pete was named Most Valuable Player and received the Leadership Award and the Most Assists Award. Pete also shared the Team Captain's Award with Jeff Tribbett.

This photograph makes a good ending to my photo record of Pete's college playing career. After the press conference, he and Assistant Coach Jay McCreary came out of the dressing room for a short while and then walked back through a small entrance between the stands. The lighting was horrible, but I snapped two quick pictures. Luckily, this one is good enough to show what I wanted to show—the end of a very long climb to the top of the mountain.

The basketball awards banquet on March 23, 1970, was the last time I saw Pete until a month before his death on January 5, 1988. I managed to get this shot looking up from below the stage and to the side of the other photographers.

The Last Time I Saw Pete Maravich

I didn't see or talk to Pete after that awards banquet for nearly 18 years. In September 1970, I moved to Starke, Florida (near Gainesville), and opened a photography studio. My brother, J.C., who is a minister and had a congregation there, had urged me to come because "the whole county doesn't have but one photographer." I visited the little town and liked it. Being young and adventurous, I quit my newspaper job and made the move.

Pete, on the other hand, went on to play professional basketball. After a little more than two years, I moved back to Louisiana and began a 32-year career as a communications director (public information officer) for the state of Louisiana. Mostly by reading the sports page, I kept up pretty well with Pete's career until he retired in 1980, but the opportunity never presented itself for our paths to cross again.

In 1987, Pete's autobiographical account of his life was published. *Heir to a Dream* was written by Pete with Darrel Campbell and Frank Shroeder. I picked up a copy and read it with interest. It explained so much that I never knew about Pete and answered many questions about his LSU days.

Word was soon out that the book would be made into a movie. Because of Pete's born-again Christianity and the efforts of LSU head basketball coach Dale Brown, Pete had begun to come back into the LSU fold from which he had more or less exiled himself after Press was fired by LSU in 1972. Pete was now becoming more visible in activities connected with the university. He said in his book that for a long time he had held a grudge about the way (as he saw it) LSU treated his dad once he was no longer with the team.

In early December 1987, I read in the newspaper that Pete would be at the Assembly Center on a Saturday auditioning boys for the role of "Pistol Pete" in the movie. I made the decision to go out and watch, even though I didn't know if I would have a chance to speak to Pete, or even if he would recognize me if I did.

On that Saturday morning, I watched in anonymity as Pete auditioned 300 or so boys between the ages of 10 and 17. They had to show off their ball-handling skills and spin a basketball on one finger for 30 seconds. After the auditions, there was a basketball clinic conducted for some of the boys by Coach Brown. When Pete finished speaking with the boys, a reporter interviewed him for the local newspaper. I moved in closer so I could at least say hello if I had the opportunity.

When Pete finished the interview, he turned and saw me. I'm sure he didn't recognize me at first, but I must have looked familiar because he paused briefly. I said, "You know, what you need is a good photographer in this movie. Who are you going to get to play me? After all, it was my photos and stories in the *Reveille*

that made you a star." It was then that the light of recognition lit up his face with a grin.

He stepped nearer and shook my hand.

"Danny Brown," I said, in case he didn't remember my name.

"I remember, Danny. How are you?"

We exchanged some pleasantries. I told him how happy I was for him in his spiritual conversion and that I particularly admired his work with the youth. I also told him that I had just read his book but, like an idiot, had left it at home. "I should have brought it for you to autograph," I told him.

"No problem," he said. "Bring it around any time."

He looked to be ready to leave for some appointment, so I shook his hand once more and said, "It's great to see you again, Pete. Keep up the good work with the kids." He thanked me and left.

On the way home, I thought to myself that he looked really relaxed, happy, and at peace. I had read in a newspaper interview a year or so before about his conversion experience in 1982. I could tell by looking at him and talking to him that it was for real.

A month later, on January 5, 1988, I was in my car listening to the radio while running errands at lunchtime. An announcer broke in with the news that Pete had collapsed and died while playing a pick-up basketball game in California. He was there to speak to a Christian youth group. Later, an autopsy revealed the cause of death to be a rare congenital heart defect; he had been born with only one coronary artery instead of the normal two. What that told me was that Pete, with only half a functioning heart, was still good enough to become the greatest basketball player ever to come down the court.

After Pete's death, Louisiana governor Buddy Roemer signed a proclamation officially renaming the Assembly Center the Pete Maravich Assembly Center. The biographical film *The Pistol: The Birth of a Legend* was released in 1991, and in 1996, Pete was named one of the 50 greatest NBA players in history by a committee composed of NBA players, historians, and coaches. He had already been inducted into the NBA Hall of Fame in 1987.

A month before his death, Pete told a sportswriter that he spoke to high school and college students, prisoners, churches, and civic groups two or three times a month. As a born-again Christian, he explained that he wanted them to understand where he had been, what he had done, and what he had become. As a Christian myself, I already know the answers to those questions. But I can give a second set of answers that are just as appropriate. Pete had been a friend. He had done the impossible with a basketball. And he had become a legend.

Pete's Final LSU Statistics

Pete's final statistics tell you a lot about how good an all-around player he really was. His final varsity offensive point total was 3,667 points, for a 44.2 average per game. He made 1,387 field goals out of 3,166 attempts, for a 43.8 percent average. He played in 83 consecutive games before having to sit out the final game of his college career against Army in the NIT because of an ankle injury.

At the free-throw line, Pete made 893 foul shots out of 1,152 attempts, a 77.5 percent average. As for rebounds, Pete averaged 6.37 per game for a total of 528. In assists, Pete had 423 for a 5.1 per-game average. In the 83 games he played, Pete had only 250 personal fouls, an average of three per game.

In his sophomore season (26 games), Pete's season point total was 1,138, for an average of 43.8 points per game. The team finished 14–12 on the season.

In his junior season (26 games), Pete's season point total was 1,148, for an average of 44.2 points per game. The team finished 13–13.

In his senior season (31 games, including post-season play), Pete's season point total was 1,381 points, for an average of 44.5 points per game. The team finished 22–10 and was fourth in the NIT.

Note on the Photography

For the photography buff, I think it is proper to go over the technical details of how the photographs in this book were taken and developed, and a little about my photography background.

By the time I got to college, I was a fairly competent photographer. I had started out with a $5 plastic camera shooting photos for my high school newspaper and yearbook. I was having the film developed at the local drugstore, but about halfway through my senior year, I purchased a darkroom kit and learned how to develop the film in my bathroom at night. I did not have an enlarger, but I could make contact prints, which are the same size as the negative.

Just after my high school graduation in 1965, my brother J.C. and I constructed a very nice darkroom, complete with hot and cold running water, in the rear of the family garage. I purchased a Bessler enlarger and all the darkroom trimmings. In the fall of 1965, my freshman year at LSU, I purchased a used Mamiyaflex 120/220 (2¼" × 2¼" negative) camera and continued shooting football photos for my old high school's yearbook.

During the first half of what was perhaps the most important district game of the year, I noticed that the photographer from the *Baton Rouge Morning Advocate* (now the *Advocate*) hadn't shown up. I had met him at earlier games, and his absence from this important game was especially puzzling. At half-time, I called the newspaper sports desk and explained to the editor that his photographer was not there and that I would gladly bring in my film for developing after the game. He agreed.

It turned out the photographer had car trouble and never made it to the game. It's important to note that the game's end turned out to be quite controversial. My old high school was favored. Behind with less than two minutes to go, the team drove down the field and scored the go-ahead touchdown with about 30 seconds remaining.

Then, on the last play of the game, the other team, who had beaten my high school only once in eighteen years, threw a "Hail Mary" pass that appeared to be caught in bounds for the winning touchdown. However, the referee said the receiver didn't have full possession of the ball in the end zone before he went out of bounds, and ruled the game was over. Well, a near riot broke out. I got pictures

of everything—the winning touchdown, the incomplete pass, and the chaos that followed the ruling.

When I arrived at the newspaper office, the sportswriters were already well aware of what had happened and were anxious to see what photos I had. The photography department developed the film for me, and they used the winning touchdown photo in a very large format in the next day's newspaper. That night, the sports department offered me a "stringer" job covering high school football games for them on Friday nights. For those who may not know, "stringers" are independent photographers or journalists who cover area games the newspaper can't cover with its own people. At that time, a stringer was paid a flat rate of $5 for each photo used. On a good night, I could cover several games and make what was then a tidy sum to a poor college freshman.

The best benefit from this job was that I became close friends with the *Morning Advocate*'s sportswriters and staff photographers. It was they who really taught me how to be a professional photojournalist. Among those who helped hone my skills were the late head photographer John Boss, along with photographers John Dobbs, Leatus Still, the late Ken Armstrong, and the late Art Kleiner. It was through them that I also met and came to know distinguished Baton Rouge photographers Dave Gleason and Fonville Winans. Dave Gleason went on to publish a number of photography books featuring New Orleans, Atlanta, Boston, Miami, and his home town of Baton Rouge. He is most well known for his photographs of antebellum homes. The artistry of Fonville Winans has been compared with that of other photographic greats, such as Ansel Adams. His photographs, taken over a span of fifty years, record the rich culture of south Louisiana's people and places. His entire collection of prints is now archived in the LSU Libraries' Special Collections Department.

I need to make a special mention here of *Baton Rouge State-Times* staff photographer Charles Gerald. He began work at the newspaper in December 1967 and became my best friend. Charlie and I remained very close until his death in December 1990, when he and his boat were lost at sea off Miami in bad weather conditions. He was simply the best photographer I have ever met. He had an eye that could see a photo where none was apparent, and that one photo would tell the whole story of what he was covering. He won numerous awards from the news services in many different categories. I learned a lot from Charlie.

As I said, the part-time job at the newspaper helped provide me with a little extra college money. Eventually, it led to working at the newspaper as a photographer for the entire summer of 1966, as a full-time staff photographer at the *Advocate* in later years, and as a full-time reporter for the *State-Times* after my graduation from LSU. During the summer months of 1966, I worked in place of any photographer who was on vacation. Since vacations ran consecutively, it was almost a full-time job. My photography skills really improved during that period.

In the fall of 1966, I began my sophomore year at LSU. That is when I met Pete while putting him through freshman orientation in the Air Force ROTC. I also began my introductory journalism curriculum that semester. I didn't yet have any class assignments for stories or photographs in the *Reveille;* however, I became friends with an upper classman who did. After a little pestering, he let me tag along and take photographs with him. It was really just practice for me because it was his grade that was on the line from the photographs used in the *Reveille.* When my junior year rolled around in the fall of 1967, I began taking photos and writing stories as class assignments for the *Reveille.*

It was in December of 1967 that I bought my dream camera, a 35 mm Nikon F. The Nikon F was in use by the best of the best photojournalists. However, these cameras were expensive, and even the photographers at the *Morning Advocate* were just getting them. I was able to purchase a used one at a local camera store for $400, a small fortune for a college student in 1967. But the camera store let me have it on a 90-day credit plan, which I managed to pay off in the allotted time because of my stringer pay. The camera came with a Photomic head (viewfinder with a built-in light meter) and two lenses, an $f/2.0$ 35 mm wide-angle lens and an $f/2.5$ 105 mm telephoto lens. This is the camera I used to photograph everything for the next several years.

That camera with the 35 mm wide-angle lens was perfect for basketball game photographs. At the time, photography had advanced enough to where almost no flashes were being used at sporting events. "Available light" was the thing. Parker Coliseum had decent lighting shining down on the court from good angles all around. It was not the best lighting in the world, but it was good enough to shoot available light.

The general practice for still photographers at the LSU basketball games was to shoot black-and-white Kodak Tri-X film with an ASA sensitivity (now ISO) rating of 400. Basketball shots could be underexposed by one and a half f-stops (making the film a 1200 ASA rating), but overdeveloped with a special developer called Acufine to compensate for the underexposure. The resulting negative had near-normal density. The camera setting was a shutter speed of 250th of a second at an aperture (f-stop) setting of 2.0.

The major drawback to this exposure and development method was that most of the photographs took on a "grainy" look that reduced their sharpness, especially when they were enlarged a lot. However, since I was shooting for reproduction in the campus newspaper, most of the graininess did not show up on the printed page. I used the above exposures and developing methods at all of the LSU basketball games I photographed.

Although the Nikon F was a manual-focus camera, the 35 mm $f/2.0$ wide-angle lens made it possible to get almost everything in focus on every shot. With the lens set on infinity, everything from about 10 feet out from the camera all the

way to infinity was in focus. For close-in shots, say under the goal, the trick was to focus on a spot and wait for the action to come to the spot. Otherwise, trying to successfully focus on fast-moving basketball players is a real hit-and-miss proposition.

Now I am not saying it was easy to get perfect exposures and good photos because it was not. Even though I was shooting available light with the *f*-stop wide open at *f*/2.0 and the focus on infinity most of the time, you have to remember that the fastest shutter speed I could use was only 250th of a second. At that speed, even when you are in perfect focus, you can get a slight blur that is not apparent until you enlarge a negative to make a print. Still, a photo like that is usable a lot of the time. I found the best way to get the sharpest print possible was to use the enlarger lens to focus on the grain of the negative when making a print. That way, you know the negative is in perfect focus, even if the subject in the negative is not. This method gives you the sharpest print possible from a blurred negative. If the "softness" (focus) of the photo is not too bad, it is not readily noticeable when the photo is reproduced in a newspaper.

Well, there you have it—a brief history of the photographer Danny Brown and the technical information of how the photographs in this book were taken and developed. These days, I still do some photography, but mostly with a digital camera and using a computer as my darkroom. Goodness, it is so much better than fighting it out in a real darkroom. And although I would like to think of myself as a great photographer, I'm really not. At least not on the level of those friends I mentioned above, particularly Charlie Gerald. However, I was a competent professional and did garner some prestigious photography awards while in college and while working for the *Morning Advocate.*

In closing, I would like to note that I had no predetermined grand plan that resulted in my career, the photographs in this book, or my brief friendship with Pete Maravich. They just happened. I think it was simply a case of being in the right place at the right time. Sometimes, that's better than any grand plan one can devise.

Taken by a friend in 1970, this is the photo that appeared on my first business card. The Nikon F camera I am holding is the one I used to shoot almost all of the photographs in this book.

Photo courtesy Bombet Cashio & Associates

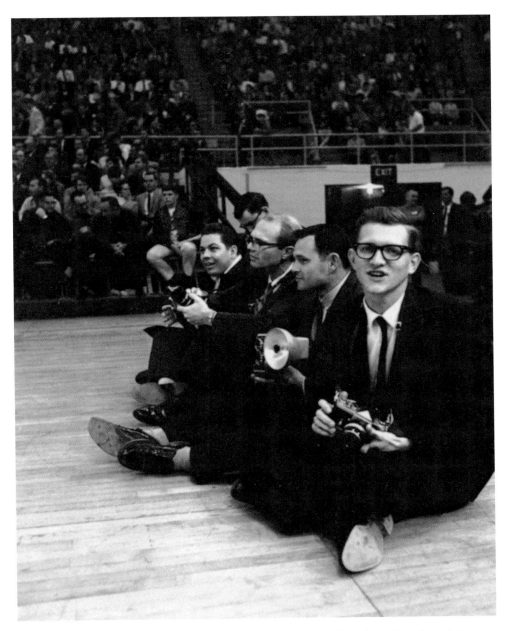

Sitting under the LSU goal at most home games were a number of regularly attending photographers I knew well. I took this photo during Pete's sophomore season, when there was still plenty of space available under the goal for photographers to position themselves. Left to right in this picture are Buddy Bombet, the late Dave Gleason, now-retired *Baton Rouge State-Times* sports editor Sam King, and former *Baton Rouge Morning Advocate* staff photographer Leatus Still. I learned a great deal about photojournalism while working with Leatus at the *Morning Advocate,* and we are still good friends.

Acknowledgments

There are so many people who have helped make this book a reality. First and foremost, I must thank my close friend Bob Courtney, who for years has urged me to publish this photographic record of Pete. He never gave up. He patiently explained time and time again that publishing these photos would not be taking advantage of my brief friendship with Pete, as I had seen others do. I am very thankful for Bob's friendship and support.

I must also thank Danny Plaisance. As a bookstore owner, he too advised me to publish this book. It was he that informed LSU Press that I had these materials and started the wheels in motion that resulted in this publication.

And of course, I can't forget my friend Ralph Jukkola, a teammate of Pete's. I am especially grateful for his friendship all these years and for his assistance in jogging my memory of events that occurred almost forty years ago.

I would be remiss not to acknowledge the help of those who were instrumental in my career as a journalist. Among these are the *Baton Rouge Morning Advocate* and *State-Times* photographers mentioned in the body of this book. Of those, I offer particular thanks to my friends Leatus Still and the late Charles Gerald.

I must also thank the late Dr. A. O. Goldsmith, my favorite professor at the LSU School of Journalism. He was a special inspiration to me. Without a certain act of assistance on his part, my college career may well have sputtered to a stop. I will never forget that kindness.

And last I must thank my family: my mother and father, who sacrificed so much so that my brother and I could have a college education; my brother, J.C., who gave me the love of photography and helped build my first darkroom; my Aunt Ollie, who was the kindest and most gentle person I have ever known; my Uncle Oscar, who aspired to be a journalist and passed that dream on to me; and finally, my wife, Cheryl, whose love and patience now anchor my life. I dearly love them all.